Graphic Design
B A S I C S

Making a Good Layout

Lori Siebert & Lisa Ballard

North Light Books
Cincinnati, Ohio

Published by North Light Books, an imprint of F & W
Publications, Inc, 1507 Dana Avenue, Cincinnati, Ohio
45207; 1 (800) 289-0963. First Edition.

96 95 94 93 92 5 4 3 2 1

Library of Congress Cataloging in Publication Data
Siebert, Lori
 Making a good layout / Lori Siebert & Lisa Ballard.—1st
 .ed.
 p. cm.—(Graphic design basics)
 Includes index.
 ISBN 0-89134-423-3
 1.Printing, Practical—Layout. I. Ballard, Lisa
II. Title. III. Series.
Z246.S56 1992
686.2'252—dc20 91-47184
 CIP
Edited by Mary Cropper
Designed by Lori Siebert and Lisa Ballard

Pages IV and V constitute an extension of this copy-
right page.

Our thanks to:
Diana Martin
for getting us started,
David Lewis
for giving us direction,
Mary Cropper
for making it happen,
Lynn Haller
for getting the permissions,
And especially to all the talented designers
who graciously supplied their work
for making it
beautiful.

Permissions

Contents

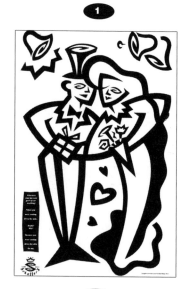

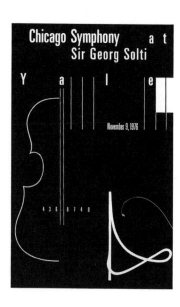

Chapter Three: The Principles of Design

The principles of design determine what you do with each of the elements and how you do it. In this chapter, we'll show you how these principles work and tell you how to apply them.

Chapter Four: More Good Examples

Designers use the elements and principles of design on every project to make good layouts. In this chapter, you'll see different types of pieces done by a variety of designers and get ideas for ways you can make what you've learned in this book work on any kind of project.

Chapter Five: A Sample Job

In this chapter, you can work along with us as we create a layout for an actual project. We'll use many of the elements and principles to create a layout that's functional, well organized and attractive.

Index

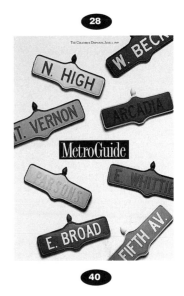
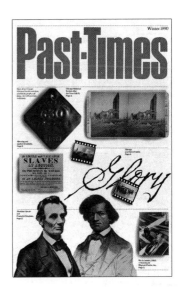

To Our Readers:

The word "design" sounds unapproachable and mysterious, so many people think they can't do design. But the reality is that everyone is involved with design every day.

Every time you choose an outfit, you make design decisions. First, you think about where you'll be, what you'll be doing, who will see you, and what image you'll want to project. Do you want to look professional at work? Do you want to grab attention at a party? Do you need something comfortable for a ball game?

You think about what outfit will look attractive to others—what the people you'll see might like. You think about what will work—you may need a jacket because it will be cold. You think about what will look organized—what shoes will match your sweater.

Designing a good layout involves similar thinking. What will the piece be? Where will it be seen? Who will see it? What results should it get? What type and visuals will give it the right effect? And design isn't magic—many layouts will be tried and discarded before the right one is found.

This book will help you apply what you've learned about design, in your everyday life, to making good layouts. You'll learn what a good layout is and how to use design elements and principles to make one. You'll learn the basics of designing different kinds of projects and find plenty of tips to use in your own layouts. We hope you'll enjoy exploring the world of design and will soon be making your own good layouts.

Chapter 1
A Good Layout Is...

A layout is the arrangement of type and art (photos, illustrations or any other graphics you might have) on paper. But what is a *good* layout? How can you tell if your layout is good? There is no one right answer, but there are some criteria to follow.

There are three basic criteria for a good layout: It works, it organizes, and it attracts viewers. It must do all three of these things, not just one or two of them. For a layout to work, it must get your message across quickly—in an appropriate manner. It must be organized so the reader can move smoothly and easily through the piece. And a layout must stand out from its competition in order to attract.

Knowing how to combine the three criteria is the key to making good layouts every time. In this chapter we'll show you examples of good layouts that are especially attractive, well organized, and that work very well. Then we'll tell you how each designer achieved that goal. We'll also give you some tips to help you make your own good layouts.

This chapter explains what a good layout does— it works, organizes and attracts.

A Good Layout Works: Does what you set out to do.

You have to know the *purpose* of a piece before you begin to design and lay it out. Getting the answers to a few simple questions up front will give you clear guidelines for creating a good, functional piece.

To have a successful party, you need to decide who will come, what you want them to do (eat, dance, talk), and where you'll hold it. You need to ask yourself or your client similar questions before starting work on a printed piece. *What* is the purpose of the piece (the message the reader should get)? *Who* is the audience for this piece? *Where* will it be seen (or *how* will it be distributed)? Knowing the answers to these questions *before* you plunge in will make it easier to decide how the piece should look. If you're working on a poster, for example, keep the layout simple, with few elements and large type so it can be easily read at a distance.

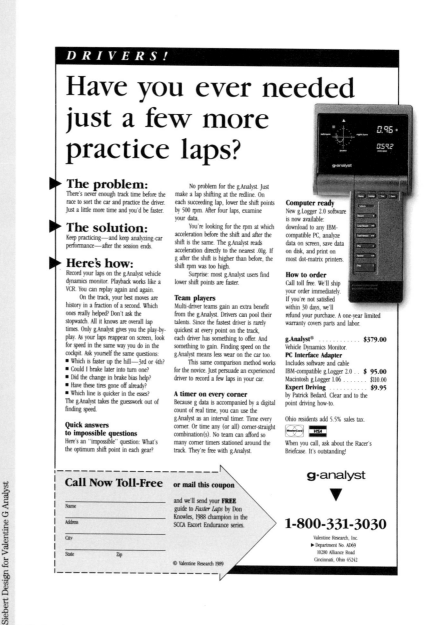

Siebert Design for Valentine G Analyst

Arrows serve as visual clues, directing readers to and through the first three subheads and then to the phone number—the call to action. Even the coupon has an arrow shape that points to the 800 number. The coupon has a screened tint to make it jump out at the reader and is in the bottom corner to make it easy to clip out. Once the black bar and reversed type at the top have caught the readers' attention, the long headline leads them into the piece. Short blurbs and easily read paragraphs continue pulling readers through the ad to the coupon and the 800 number.

MERCY
Health System

2335 Grandview Avenue
Cincinnati, Ohio
45206 • 2280

513 • 221 • 2736

HEALTH MINISTRY OF THE SISTERS OF MERCY ▪ PROVINCE OF CINCINNATI

Siebert Design for Mercy Hospital

MERCY
Health System

2335 Grandview Avenue
Cincinnati, Ohio
45206 • 2280

The small blue squares on the stationery aren't just for decoration: They show the typists where to begin the return address and the letter itself. On the envelope, the blue square indicates where the mailing address goes. The peach colored, rayed squares show where to fold the stationery. These touches help ensure that all letters and other documents will always be typed and folded the same way, not only to make the typists' job easier but also to give all the hospital's communications a consistent, professional look.

To help your layout function:

• Determine the piece's main message and plan your layout around it. (Choose a photo that supports that message.)

• Size the piece to fit its use. (If it's a brochure, make it a size that can be easily held and filed.)

• Keep in mind where the piece will be seen. (A magazine's title should be easily seen when it's in a rack.)

• Keep your target audience in mind when sizing photos and choosing type sizes. (Make everything larger and easier to see if the audience is older.)

• Check with the post office to make sure it can be mailed. (There are regulations affecting size, weight, location of information, and type of fold.)

• Choose a paper stock that will work in a laser printer— for letterheads, newsletters, flyers—if that's how the piece will be printed.

• Choose a light colored paper and a dark ink if the piece will have to be copied on a photocopier.

• Make sure that a logo is clear and readable at all the sizes it will be used.

A Good Layout

Organizes:

You need to help readers get through your piece easily. If they have to work at reading it—they won't bother. To make a good, effective layout, make it easy to follow.

Arrange and emphasize information to make your message as clear as possible. This is like drawing a map to show a stranger how to get somewhere. Choose what the reader should see or read first. Where should it be? How will you make it stand out from everything else to show where to start first?

Then decide what must come next. What bit of information—words or picture(s)—will best build on the first bit to make your message clearer? ("And when you reach the corner, turn left onto Elm.") Where and how does it follow that first bit? What separates it from all the information that will come after it? Continue arranging and emphasizing (or finally not emphasizing) all the information until everything has been seen and understood. ("It's right across the street from a purple house.") The better you organize the layout—direct your readers through it—the faster they'll get your message.

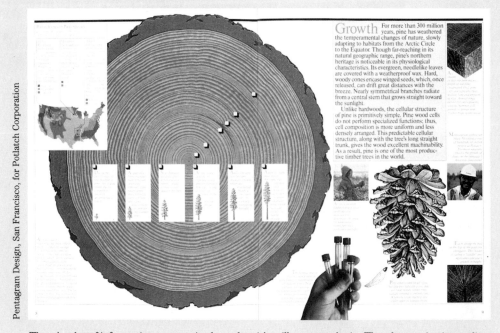

Pentagram Design, San Francisco, for Potlatch Corporation

There's a lot of information to organize here, but it's still easy to take in. The photos give immediate, visual clues as to what this spread is about. The largest visual tells what the main theme of the layout is. A tinted box behind large type tells readers what to read after they've looked at the main visual. The pictures get progressively smaller to show what comes next and then next. All the captions are the same size type so you can quickly see they're all the same kind of information.

Maps out a visual path for readers to follow— shows what comes first, second, third, etc.

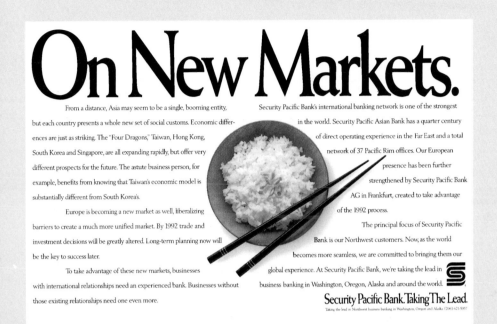

In each ad, the large headline says, "Read me first!" The central *visual* (picture) supports the headline and draws readers into the ad. The logo and tag line in the lower right-hand corner pull the eye through the ad. The readers know the most important points of the message now and can read the body copy last for the details. Even if they skip the body copy altogether, they'll still know who the advertiser is and what's being offered.

To help organize a layout:

- Use different sizes of type. (Headlines are bigger than subheads.)

- Put colors behind an important area of information.

- Use rules to separate information into groups.

- Change the weight of the type. (Semibold stands out, but bold *really* stands out.)

- Leave white areas around information.

- Pick the best location. (The upper left corner is usually read first.)

- Align similar kinds of copy.

- Put pictures next to important copy. (They attract the eye and reinforce the message.)

- Put type in a box or give it an interesting shape.

- Call out items by putting bullets in front of them as we've done here.

- Change the style of type.

- Use different colored or reversed type (white on black) to separate and emphasize.

A Good Layout Attracts:

A piece can't communicate unless it gets noticed. To get noticed, it has to stand out from the crowd by being different from everything around it. Depending on the piece, that can mean being startling, pretty, surprising, entertaining, unusual, or simple and direct. How do you know which one to choose?

The approach you will use (*how* you'll do it) depends on the piece's audience (*who* will read it) and its environment (*where* it will be seen). A person wearing bold colors would not stand out at a beach party but would definitely turn heads at a black-tie affair.

The same is true of a printed piece. Newspapers look gray because they are made up with a lot of type. Therefore, an ad with either a lot of black areas or white areas will attract more attention. Suppose you're designing a brochure for a general contractor and observe that all the other contractors' brochures are predominantly navy blue. You choose a different color—bright yellow because it's Sun Contractors. Which brochure will get noticed first?

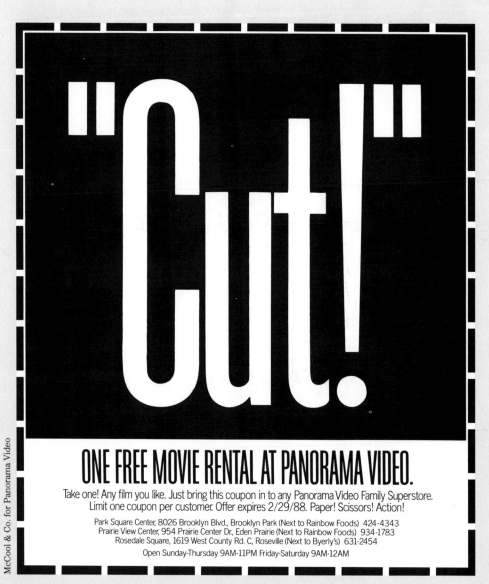

McCool & Co. for Panorama Video

The unusual format of this ad—it's a giant coupon—helps attract attention to it. The huge, one word headline jumps out at the reader and introduces the piece's message with humor, making a play on the word "Cut." Since this is an ad for a chain of video stores, "cut" suggests both the movies' use of the word and "Cut out this ad/coupon now!"

Grabs your readers' attention and pulls them into your piece.

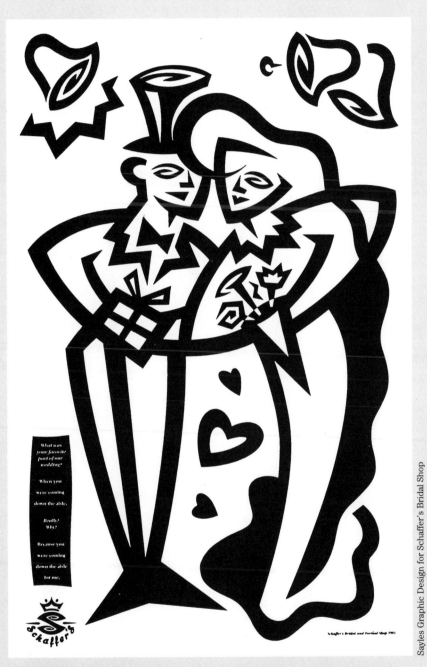

The nontraditional illustration style attracts attention immediately. This is decidedly not the typical look for a bridal shop. The design, which looks like wrapping paper, adds excitement to these pieces. Though the use of black and white does reflect traditional bridal and formal wear colors (white wedding dress and black tuxedo), it gives the piece a dramatic contrast in color as well.

To create an attractive layout:

● Enlarge a photo of something small, such as a bee, so it will cover an entire spread.

● Tilt an image or a block of copy at an angle.

● Surround a very small picture or bits of type with a lot of open space.

● Choose bright colors when the piece will be viewed in a gray environment, such as a text-heavy magazine.

● Use a solid black area or a large white area for a newspaper ad.

● Crop an image in an unusual way. (Show an eye, not a whole face.)

● Use very large type for a thought-provoking or humorous headline.

● Make the piece a different size and shape from other similar pieces. (Use a square envelope if everyone else is using a #10.)

● Choose a paper with an interesting, noticeable texture or color.

● Set important information in an atypical way. (Set a headline on a curve or try a script font or face.)

Conclusion:

What is a good layout? A good layout works, organizes and attracts. It must do all three of these things, not just one or two of them. So let's review how a layout meets each goal.

- A good layout works: Does what you set out to do. You need to know what the purpose of the piece is, who it is for, and where it will be seen or how it will be distributed.

- A good layout organizes: Maps out a visual path for readers to follow—shows what comes first, second, third, etc. You must order the information to make your message as clear as possible.

- A good layout attracts: Grabs your readers' attention and pulls them into your piece. It has to stand out from the crowd by being different from everything around it.

● Now that you've seen examples of good layouts that are especially attractive, well organized, or that work well, you're ready to try making your own. Remember that good layouts don't appear like magic. You must be willing to experiment. The process is similar to doing a jigsaw puzzle: You keep putting the pieces together different ways until they all fit comfortably.

● There is no one right way to make a good layout. There are as many different ways to make a piece work, be organized, and look attractive as there are designers. Always ask yourself these questions about each layout you do: Does it work? Is it organized? Is it attractive? If you can answer "yes" to each, you'll know that you've made a good layout—no matter how you did it.

Chapter 2

The Elements of Design

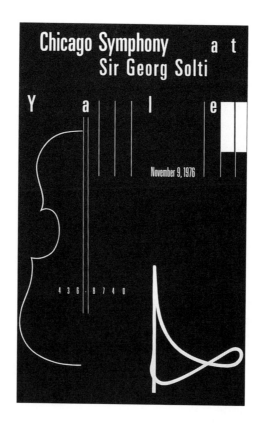

Chicago Symphony a t
Sir Georg Solti

Y a l e

November 9, 1976

4 3 6 · 8 7 4 0

In order to make anything, you have to start with the basic materials . You need bricks and mortar to create a building. You need flour, eggs, butter, and other ingredients to make a cake.

The ingredients for making a good layout are the elements of design: line, shape, texture, space, size, value and color. There is nothing mysterious about any of these; in fact, you're already familiar with most of them from your everyday life. Just as the same ingredients can be used to create different dishes, the elements of design can produce different layouts depending on how they're used.

When you understand what it is that each ingredient adds to a recipe, you can make up your own recipes. If you make the right choices about what to put in your new recipe, you will succeed in making a good dish. The same is true of using these ingredients of design. Once you understand what the elements of design are and how they work, you can make the right choices to create your own good layouts.

This chapter introduces the ingredients for a good layout—the elements of design. These are line, shape, texture, space, size, value and color.

Line: Any mark connecting any two points.

Lines are everywhere. Look around you. They're straight (a pretzel stick), curved (the neck of a swan or a crescent moon), or squiggly (a snake wiggling through the grass). Lines can also be fat, thin, or dotted (as in "Just sign on the dotted line.").

Lines can be used for different things. They organize (show where to color in a coloring book), direct ("Follow the yellow brick road."), separate (the lane lines on a highway), suggest an emotion (a jagged line of lightning can look violent), or create a rhythm (a picket fence).

You can use lines to do the same things in your layouts. A *rule* is a line that separates one part of your layout from another. Vertical rules can be used to separate columns. You can use dotted or dashed lines to connect information: Food items on a menu are often linked to their prices this way. You could use curved lines to suggest a stringed instrument and convey elegance and beauty (like a swan) in a symphony poster.

The type follows the path of an imaginary ball that changes direction as it hits the edges of the piece. The type leads viewers to the visual of the product to reinforce the connection between the two. The strong baseline pulls the eye so readers will follow the copy.

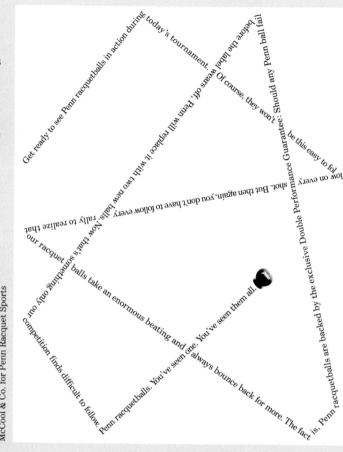

McCool & Co. for Penn Racquet Sports

Exercise

In this exercise, you'll create a variety of lines that evoke different moods or feelings to discover what effects you can achieve. Draw a row of thin, straight lines with a sharp pencil on a piece of paper. On another piece of paper, draw a row of loose, curvy lines with something that will make a broad, soft line—lipstick, paintbrush, or crayon. Don't make your row neat and tidy like the pencil lines. On a third sheet of paper, use a marker with a fairly fine point to draw several jagged lines across the sheet. Compare the three sketches. Do the pencil lines look stiffer and more formal? Mechanical or hard-edged? Neater and better organized than the other two? Do the curvy lines look softer and more delicate? Do they suggest quiet and calm, or activity? How about the jagged lines? Do they look sharp and angry? Do they suggest motion or action?

Making a Good Layout

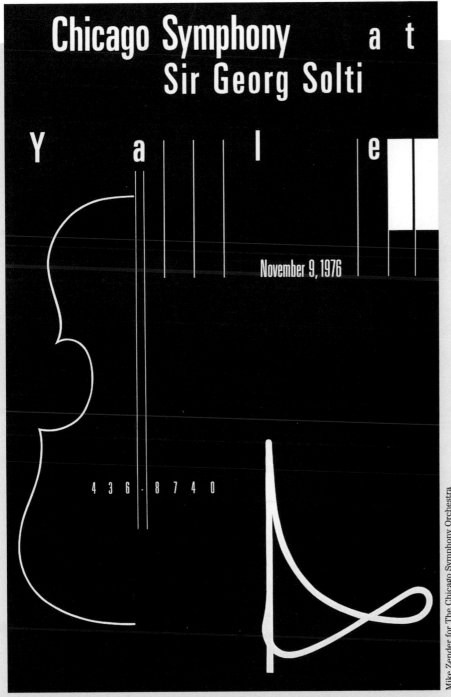

Chicago Symphony at
Sir Georg Solti

Y a l e

November 9, 1976

4 3 6 - 8 7 4 0

Lines serve three purposes in this piece. They create a sense of *motion*. The line in the lower right mimics the movements of a conductor's baton. Lines suggest the *shape* of a stringed instrument and piano keys. The arrangement of the "piano keys" and the type create a pleasing *rhythm* paralleled by the arrangement across the top of the piece. The result is a symphony poster that captures the elegance of a concert and the rhythm of music.

Mike Zender for The Chicago Symphony Orchestra

With line(s) you can:

● Organize information. (Place lines between the columns of numbers in a financial report.)

● Highlight or stress words. (Set off a headline with a rule.)

● Connect bits of information. (Link a caption to the photo it is describing with a line.)

● Define a shape. (Arrange a line of type in the outline of a Christmas tree.)

● Outline a photo to set it off from other elements. (Run a thick line around a photo as a border.)

● Create a grid. (Separate items into columns for a catalog.)

● Create a graph. (Draw a line across a grid to show profit and loss over time.)

● Create a pattern or rhythm by drawing many lines. (Vary thick and thin lines and the spaces between them.)

● Direct the reader's eye or create a sense of motion. (A diagonal line looks more active than a horizontal one does.)

● Suggest an emotion. (Use a a curved line in a ballet poster to suggest elegance.)

Shape:

Anything that has height and width.

Everything has a shape. Children learn to identify objects by learning their shapes. They learn that one shape is a pear and that another shape is an apple. They draw simple geometric shapes to illustrate the world: A circle can be the sun. When they begin to read, they discover that letters have different shapes: This shape is *a* but that shape is *w*.

In design, shapes still define objects but they also communicate ideas. In a logo for an international company, a circle could suggest the earth.

Unusual shapes attract attention. People are so accustomed to seeing rectangular photos that photos set in unexpected shapes such as stars catch the reader's attention. Arranging type in a shape other than a vertical column (a rectangle of type) can also add interest.

There are three different kinds of shapes. *Geometric* shapes—triangles, squares, rectangles, circles—are regular and structured. This makes them great building blocks for design. *Natural* shapes—animal, plant, human—are irregular and fluid. Borders that look as if they're made of ivy vines have an airy, open feeling . *Abstracted* shapes are simplified versions of natural shapes. The symbol denoting facilities for the handicapped (a stylized figure in a wheelchair) is an abstracted shape.

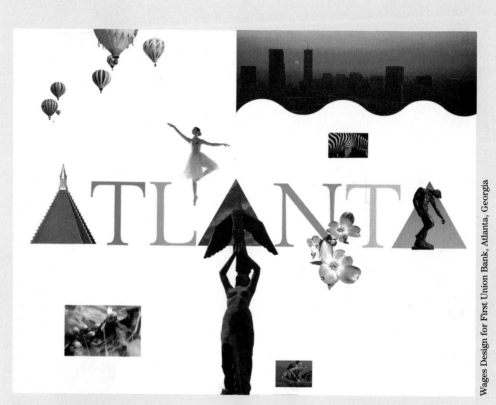

Wages Design for First Union Bank, Atlanta, Georgia

Shapes can add fun and excitement to any piece. Many of the photos on this cover have been outlined to show off their interesting shapes, and the Atlanta skyline is enhanced by a ripple effect. The repetition of the triangles as letterforms in the word *ATLANTA* provides a steady rhythm to pull the piece together.

Exercise:

The shapes you'll work with in layouts will actually be blocks of copy or visuals. But they're still basically shapes, so for this exercise we'll work with solid shapes. Cut six rectangles in the following sizes out of a single sheet of colored paper: 4¾"x1⅝" (12cm x 4cm), 1¾"x1½" (4.5cm x 4cm), 3¼"x2½" (8.5cm x 6.5cm), 2½"x1½" (6.5cm x 4cm), 2⅜"x1¾" (6.5cm x 4.5cm), and 1½"x3¼" (4cm x 8.5cm). Use them to create different arrangements of shapes on an 8½x11" (size A4) sheet of white paper, looking for pleasing combinations. After you complete each layout, make a quick sketch of it so can compare them later. When you've made as many layouts as you want (but more than one) study them all. Ask yourself which layouts you like best and why you like them. How would you change those you don't?

Making a Good Layout

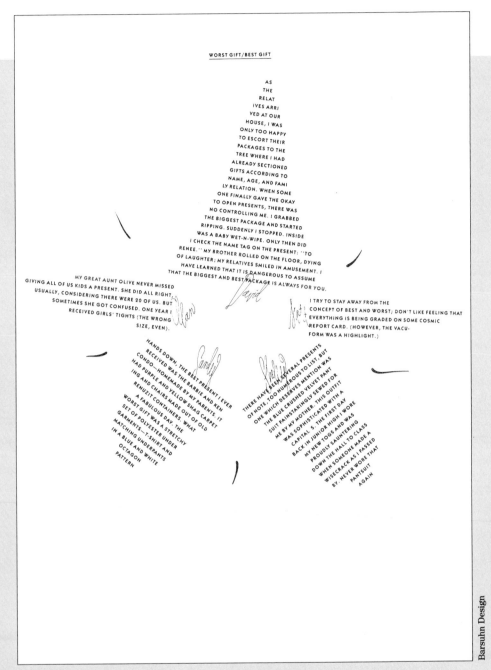

Barsuhn Design's 1990 Christmas card features the Christmas memories of the five people who make up their staff. The type for each page of memories has been arranged in a different shape—star, present, Christmas tree and ornament. To add playfulness to this typographic illustration, the designers allowed a little irregularity to occur, but you still can see the shape is a star.

With shape you can:

- Crop a photo in an interesting way. (Drop it into an oval.)

- Symbolize an idea. (A heart symbolizes love.)

- Make a block of copy more interesting. (Set the copy for a Fourth of July ad in the shape of a star.)

- Create a new format. (Make the whole brochure the shape of a triangle.)

- Highlight information. (Run a screened or tinted shape behind important copy.)

- Imply letterforms. (Use a triangle to represent the letter *a*.)

- Tie the piece to the subject matter. (Use geometric shapes on an architect's brochure and natural, curvy shapes on a zoo brochure.)

- Tie together all the elements on a layout. (Use square bullets and square copy blocks and crop photos square.)

Texture

The look or feel of a surface.

The world would be very dull without texture. Imagine a tree without its rough bark or a leopard without its fur.

You can use texture to add richness and dimension to your layouts, too. *Tactile texture* can actually be felt. If you print a piece on uncoated, rough paper or use *embossed* type (printed to create a raised surface), you'll give it tactile texture. *Visual texture* creates the *illusion* of texture on the printed piece. Wallpaper is often printed so it appears to be made of a fabric such as linen. Even blocks of type have visual texture from the patterns of light and dark created by the letters and the spaces between them.

Pattern is actually a kind of visual texture. When an image or a line of type is repeated over and over—on wrapping paper, for example—the rhythm of the lights and darks adds dimension to a surface. That's why patterns make wonderful backgrounds or borders in layouts.

Communicate on an extra level—through a real or imagined sense of touch. A repeated pattern of roses creates a feeling of elegance. Printing on a softly textured paper with light pastel colors suggests delicacy. You can also use texture for emphasis. Heavy black type against a soft pattern or texture reinforces the impact of the type.

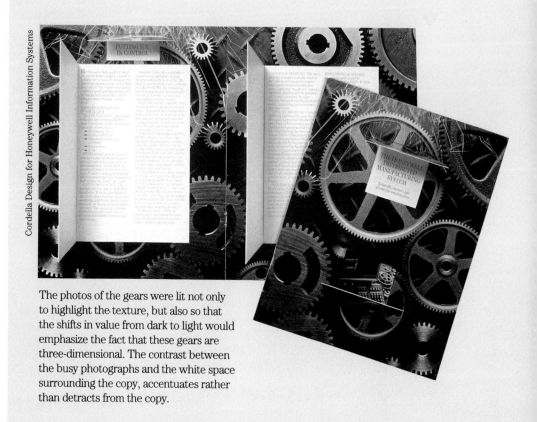

Cordella Design for Honeywell Information Systems

The photos of the gears were lit not only to highlight the texture, but also so that the shifts in value from dark to light would emphasize the fact that these gears are three-dimensional. The contrast between the busy photographs and the white space surrounding the copy, accentuates rather than detracts from the copy.

Exercise

Collect different materials that have a visual texture—pieces of patterned wrapping paper or wallpaper, blocks of type, pieces of shiny paper, photos of subjects such as leaves, trees or grass (anything with texture), etc. You'll also need pieces of colored paper without much texture. Create several collages to explore which textures look good together and which textured pieces worked well with the colored papers. Which collage do you like best? Why? Do some parts of one collage look better than others? Try to decide why. Maybe some parts have too many textures, maybe some don't have enough variety, or maybe some of the sections worked well separately but don't look good when you study the layout as a whole. If you find that you like some particular combinations of textures or combinations of textures and colors, start a file of these to use when you're making layouts.

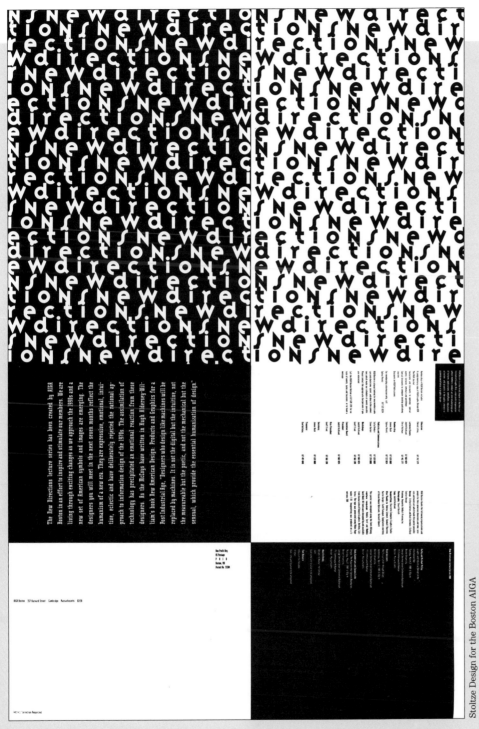

The designer turned the type on this poster for the Boston AIGA into a textural statement by repeating the same letterforms in the same sequence for a wrapping paper effect. The nontraditional letterforms combine with the negative leading and wide letterspacing to create a feeling of exciting and vigorous rhythm and movement.

You can use texture to:

● Relate an image to its background. (Run a floral pattern around a photo of an elegant, floral picture frame.)

● Give the piece a mood or a personality. (A piece done on soft, textured paper stock gives a feeling of warmth.)

● Create contrast for interest. (Run a solid color around a very textural photo or illustration, or around a block of type.)

● Fool the eye. (Create a wrapping paper pattern by repeating type to add dimension and visual texture.)

● Provoke a particular emotion. (A piece with pictures of trees and flannel shirts produces a different reaction than a piece with pictures of chrome and glass objects.)

● Create a feeling of richness and depth.

● Add liveliness and activity. (Foil stamp a word or two on a letterhead.)

Space: The distance or area between or around things.

When designing a layout you need to consider not only where you'll place each line and shape, but also where they'll be relative to each other. You must think about how much space you want around and between each element. It's similar to arranging furniture. You have to consider how much space you have. ("Can I get everything in here and leave room for people to walk around?") You have to think about how the type and images will work together. ("Should the couch face the fireplace or the television?") And finally, you have to consider how it all looks. ("Does it look funny having the tall bookcase next to the couch?")

Even when you have a lot of elements in a piece, you still must have some blank areas free of images and text (*white space*). This open space provides rest for the eye and visually organizes what's on the page. The white space between columns of type on the pages of books provides boundaries to help the reader move through text easily.

The placement and the value of the shapes on the page create spatial relationships and *focal points* (centers of interest). If you surround a big word with a lot of white space, the reader's eye will be drawn directly to that word, even if there are a lot of words elsewhere on the page.

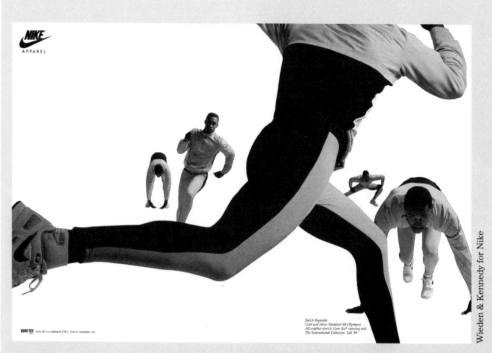

Wieden & Kennedy for Nike

This ad has a very striking dimensional quality. The large figure that bleeds off the page appears to leap into the viewer's space, an effect that is enhanced by overlapping that figure onto two others to bring it farther forward. Contrasting the largest figure with the smallest makes the smaller look farther back in the piece, adding to its dimensional quality. White space has been used quite effectively to create a sense of motion. Having the largest area of white space located at the left-hand side reinforces the illusion that the runner is moving off the page.

Exercise

Effective use of space helps make your layouts attractive, organized, and functional. Cut several ads that are roughly the same size from a magazine or newspaper. Study the white space in each. How much white space does each ad have? How has it been used? Does it separate elements from one another or tie them together? Does it set off an important element, or create a border inside the piece? Is there enough white space or too little? Now compare the ads. Which are most effective in terms of white space? Why?

Space is also important in working with type. Collect samples of type that look different—dark, light, big, small, many words or few words. Which samples are easier to read than others? Why? As a general rule, you'll find that the samples you found easier to read are those that have the right amount of space around the type to make clear what goes together and what doesn't (although the spacing around type is sometimes deliberately made extremely large or small to achieve a special effect).

Making a Good Layout

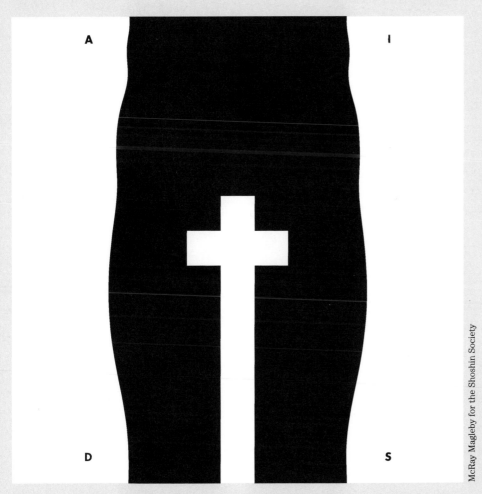

A I

D S

McRay Magleby for the Shoshin Society

This dramatic poster effectively creates negative shapes with space to deliver its message about AIDS and safe sex. The white spaces that border the piece create the illusion that the black space is a figure. The cross created by the white space inside the black area symbolizes both the genitals and death—the major cause and consequence of AIDS.

You can use space to:

• Give the eye a visual rest. (Leave plenty of white space on a spread otherwise filled with copy.)

• Create ties between elements. (Put less space between elements to make them look related.)

• Form positive and negative shapes.

• Give a layout a three-dimensional quality. (An element that is overlapped by another looks as if it's farther back.)

• Highlight an element. (Put a lot of empty space around something important.)

• Make a layout easy to follow. (Put ample margins around a piece.)

• Create tension between two elements. (Place two photos so they are almost touching each other.)

• Make a page dynamic. (Have unequal spacing between elements.)

• Make type as legible as possible. (Allow comfortable spacing between letters, words and lines of type.)

Size:

How big or small something is.

Size can function: We buy a car that fits the size of our family. Size can attract: We are in awe of huge skyscrapers and tiny babies. Size can organize: We line up kids shortest to tallest for a procession.

Size plays an important role in making a layout functional, attractive and organized. You have to consider the size of the piece itself. Will its use limit its size—must it fit into a #10 envelope? Or does attractiveness come first—should it be oversized so it catches the eye when it's received?

To make a layout functional, select type sizes and images that are easy for the intended viewer to see and read from the intended viewing distance. In a brochure for a retirement home that is targeted to potential residents, make sure the type is large enough for an older person to read. Use size to attract by contrasting large and small elements or take a photo of a very small object and blow it up so it *bleeds* off (extends beyond the trimmed edge of) the page. To help organize your layout, make the first thing you want the viewer to see the largest, and the least important element the smallest. Headlines are usually larger than the text that follows them. (Large objects appear closer than small ones, so you can reinforce importance by using size to create artificial spatial relationships.)

Here the designer has turned numbers into a visual to attract readers. The oversized numbers that bleed off the page surprise the eye and then lead to the author's name and the book title. Although it's more usual to emphasize the most important word in a title, the large *21* will definitely make the piece stand out in its environment.

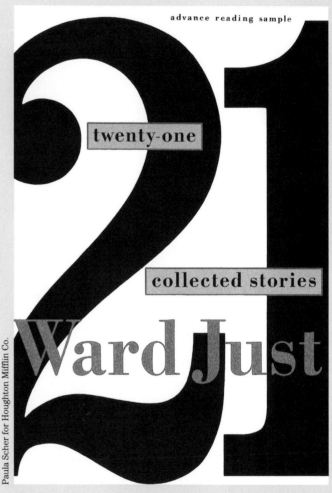

advance reading sample

twenty-one

collected stories

21

WardJust

Paula Scher for Houghton Mifflin Co.

Exercise

In this exercise, you'll see the effect of size on a layout. Cut ten 1" (2.5 cm) squares from a piece of colored paper and ten 3" (7.5cm) squares from another sheet of the same color. First, try out different arrangements of only the small squares on an 8½"x11" (size A4) sheet of white paper. Make a sketch of each layout so you can compare them later. Select the ones you feel are the most attractive and set them aside. Repeat the exercise using only the large squares. Let some overlap each other or bleed off the page. (You don't have to use them all.) Finally, repeat the exercise using some small and some large squares.

Compare the most attractive of the small-only, large-only, and large-small layouts to each other. Which have elements that stand out? Which are more attractive?

Kit Hinrichs, Pentagram Design, for the Art Center

Size contrasts add interest to this cover. The bottom photo has been enlarged and cropped so it looks larger than life. Contrasted with it are the small photos and illustrations right above it. The proportions of this piece are also attractive. The size of the piece (tabloid) lets the designer work with a big visual with lots of impact. The big photo occupies roughly two-thirds of the cover, but it's balanced by the activity of the type and pictures in the other third.

With size you can:

- Show which element is most important by making it the biggest.

- Make elements come forward or recede on the page. (Larger ones tend to come forward.)

- Give the reader a sense of scale. (In a photo, show a hand with an object for comparison of size.)

- Make all elements easy to see. (Use bigger type and pictures on a poster that will hang on a wall.)

- Get a piece noticed. (If you mail it in an envelope that's larger or smaller than a #10—regular business letter size—it will attract more attention.)

- Contrast two elements to add interest. (Put a large photo beside a tiny line of type.)

- Break up space in an interesting way.

- Make elements fit together properly in the piece. (Set type in a small size to make room for more pictures.)

- Establish a consistent look throughout a brochure or newsletter. (Make all heads the same size.)

Value: The darkness or lightness of an area.

Value gives shape and texture to everything around us. Although colors have value (a *dark* red dress with a *light* red jacket), it's often easier to visualize values in terms of black and white. If you take a black-and-white photo of a street, shadowed areas will appear black, light-colored houses will appear white, and other areas will be shades of gray between those two extremes. The way that tree trunks are shaded with grays from the lightest to the darkest parts tells us they are round. Also, the dark and light patterns created by the uneven surface of the trunk tells us it has texture.

Every element in a layout has value. Because value is relative, an element's value can be affected by its background and other elements around it. Setting a lot of type in a small area of white paper will make the paper look as if it has turned gray.

Value is an important tool for expressing your theme. You can use *slight* variations from light to dark (*low contrast value*) to create a calm, quiet mood. Soft, grainy photos set against a pastel background create such a mood. Using a *great* variation from light to dark (*high contrast value*) conveys a feeling of drama or excitement. A yellow and black striped background could communicate excitement.

Here, the different values of type help organize the piece. The reader follows the dark type and then the lighter type. The contrasts between the dark and the light type and the dark type and the white background will attract attention to the piece.

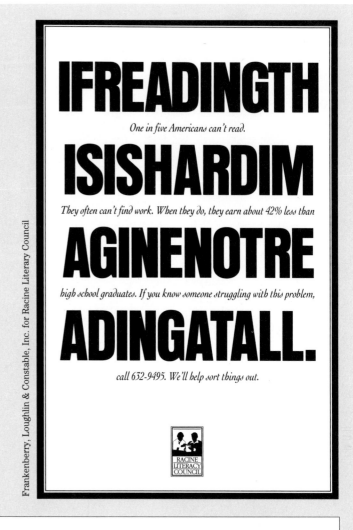

Frankenberry, Loughlin & Constable, Inc. for Racine Literary Council

Exercise

To begin working with values, create a value scale. Get some black and some white acrylic paint. Draw a row of twenty 3" (7.5cm) squares on white paper. Paint a white square. Then add a little black paint to the next one. Keep painting squares, adding more black each time, until you get an almost black one. (You may need more than twenty squares.) Then paint a black square. Cut out the squares and lay them next to each other until you find ten that go from black to white with each square looking about the same amount darker than the one before it. Now use your value scale to create some collages. Create three collages by tearing pieces from magazines—one where the pieces have values that match the lightest four squares, one where they match the darkest four squares and one that uses pieces that match both the four lightest and the four darkest squares. Compare your collages. What mood does each create? Calm? Somber? Peaceful? Dramatic?

Making a Good Layout

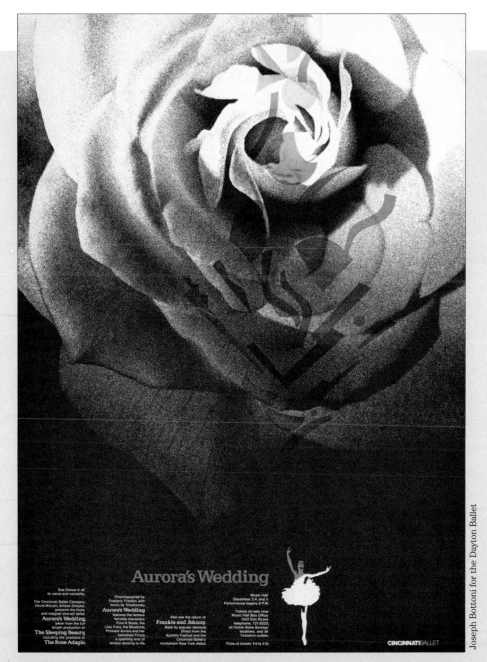

Aurora's Wedding

See Dance in all
its verve and versatility.

The Cincinnati Ballet Company,
David McLain, Artistic Director,
presents the lively
and magical one-act ballet
Aurora's Wedding,
taken from the full-
length production of
The Sleeping Beauty,
including the premiere of
The Rose Adagio.

Choreographed by
Frederic Franklin with
music by Tchaikovsky,
Aurora's Wedding
features the famous
fairytale characters
Puss N Boots, the
Lilac Fairy, the Bluebirds,
Princess Aurora and her
betrothed Prince,
a sparkling kind of
fantasy dancing to life.

Also see the return of
Frankie and Johnny.
Back by popular demand.
Direct from the
Spoleto Festival and the
Cincinnati Ballet's
triumphant New York debut.

Music Hall
December 3,4, and 5
Performance begins 8 P.M.

Tickets on sale now:
Music Hall Box Office
1243 Elm Street,
telephone, 721-8222,
all Home State Savings
locations, and all
Ticketron outlets.

Price of tickets: $4 to $10.

CINCINNATI BALLET

Joseph Bottoni for the Dayton Ballet

The value contrast between the type and its background, and the accent provided by the little figure of the dancer, which is the second lightest element in the piece, draw the eye through the poster to the type. Value also contributes to the piece's mood. Having the lighter area at the top and the darker area at the bottom gives the piece a light, airy quality, but the value changes are kept gradual to create a soft, quiet feeling.

With value you can:

• Visually separate different kinds of copy. (Use large type and heavy leading for body copy—lighter value—and tightly packed, smaller type for sidebars—darker value.)

• Lead the eye across the page. (Run a dark to a light graded tone or tint in the background.)

• Create a pattern, such as a checkerboard effect.

• Give the illusion of volume and depth. (Shade a shape to make it look three-dimensional.)

• Give a piece an understated, subtle feeling. (Use only light values.)

• Make a layout dramatic. (Use areas of black against areas of stark white.)

• Emphasize an element. (Make the most important element very light and all the others dark.)

• Make objects appear to be in front of or in back of each other. (Dark areas recede in space.)

Color: The ultimate tool for symbolic communication.

Color does many things in our lives. It helps us identify objects: Apples are red. It helps us understand things: Green means go. And it helps us communicate feelings and moods: We say we feel blue when we're sad.

In your layouts color will convey moods, identify objects, and relay messages. For example, using soft pastels in an ad can suggest a quiet or romantic mood. Putting a colored box behind a group of photos says they all belong together. An important warning might be printed in bright red type.

Color adds a lot to a layout. But when selecting colors, think carefully about what you want the color to do. What color is most appropriate? Will green or gold better suggest wealth in a piece for a bank? What color appears on pieces for similar companies? Should this piece look like the others or be very different?

How you use color makes a difference in the final result. Pick up a color from a photo for a background color in the piece, and you get a certain look. If you have a photo of a sunset and repeat those colors in the background, you'll have a piece with a gentle, soft feeling. Use a contrasting color with the same photo, and you'll get a different look. Surround a photo of a sunset with lots of black, and you'll have action and drama instead.

Printing all the photos in soft, subtle shades of blue reinforces the headline "Am I Blue?" in a very direct way. This monochromatic piece would stand out in any magazine environment. Having color would set it off from heavy text or black-and-white pieces while using only one color will set it off from multicolored pieces.

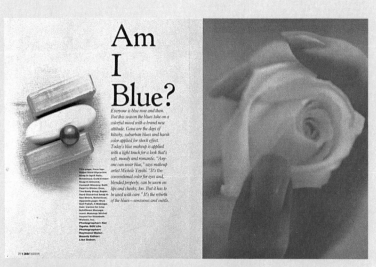

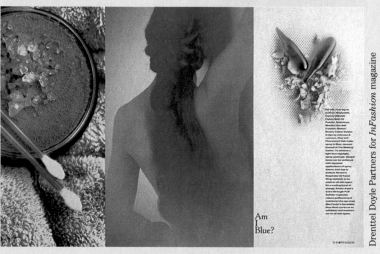

Drenttel Doyle Partners for *InFashion* magazine

Exercise

You can create dramatically different effects by using color. Tear several sheets of different shades of blue paper and a sheet of orange paper into pieces. Create a collage on a sheet of 8½"x11" (size A4) white paper using only the blue pieces. Then make a collage that combines the blue and the orange pieces on another sheet. What impression or feeling does each create? Which is more peaceful? Which is more exciting? Now, lay a black-and-white photo (any photo) on top of each. Does the photo stand out better on one? Does one layout look confusing? Repeat the exercise creating one collage from pastel colored papers and one from bright colored papers. How do these differ? Lay a black-and-white photo against each. Which works best?

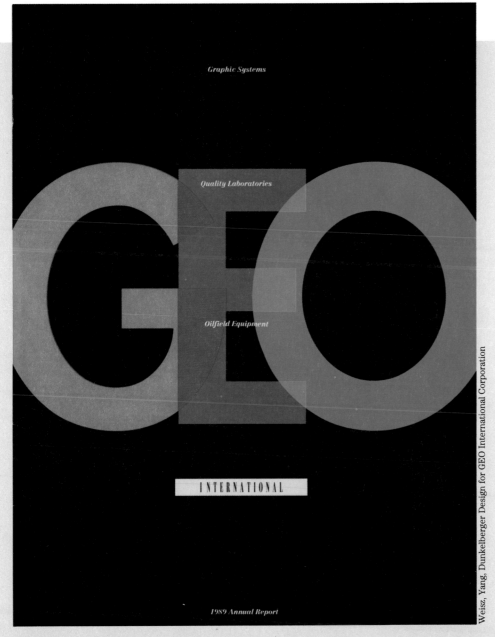

Graphic Systems

Quality Laboratories

Oilfield Equipment

GEO

INTERNATIONAL

1989 Annual Report

Weisz, Yang, Dunkelberger Design for GEO International Corporation

Color gives life to a simple layout. Showing three colors blended together reflects the company's three divisions that are combined into one corporation. The overlapping effect is created by changing the color on different parts of the *E*. The contrast between the black background and the colors on the cover makes those colors really pop.

You can use color to:

• Highlight important copy. (Run all subheads in red so they'll stand out.)

• Attract the eye.

• Tell the reader where to look first. (Copy in a red circle will be read first.)

• Make elements appear to vibrate, creating a feeling of excitement. (Try purple and green together, or orange with blue.)

• Tie a layout together. (Repeat a color from a photo or an illustration for the background, or as colored type.)

• Organize. (Color code parts of a manual or training document.)

• Set off different parts of a chart or graph.

• Create a mood. (Bright colors convey excitement while pastels soothe.)

• Group elements together or isolate them. (Set off an important block of copy by putting it on a tint, or wrap a tint around several pictures.)

• Provoke an emotional response.

Conclusion:

The elements of design are the ingredients for making a good layout. Which elements you choose and how you combine them will depend upon the type of project and the message or feeling you want to communicate. Let's review the elements of design and how they can work; understanding this information is the key to making the right choices for a layout.

- Line: Any mark connecting any two points. It can organize, direct, separate, or suggest emotion in a layout.

- Shape: Anything that has height and width. Shapes define objects, attract attention, communicate ideas and add excitement.

- Texture: The look or feel of a surface. Texture adds richness and dimension, emphasizes, and suggests mood or feeling.

- Space: The distance or area between or around things. Space separates or unifies, highlights, and gives the eye a visual rest.

- Size: How big or small something is. Size shows what's most important, attracts attention, and helps you fit your layout together.

- Value: The darkness or lightness of an area. Value separates, suggests mood, adds drama, and creates the illusion of depth.

- Color: The ultimate tool for symbolic communication. Color conveys moods, attracts, highlights important copy, and organizes.

The next time you find yourself staring at a blank piece of paper or a mound of type and pictures, review the role of each element. Decide whether it is an appropriate ingredient and how it might be combined with others to make a good layout.

Chapter 3
The Principles of Design

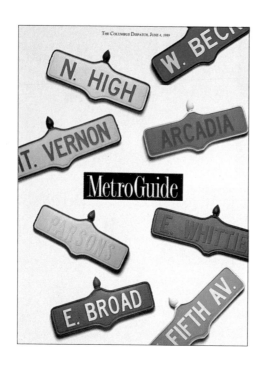

The principles of design determine what you do with each of the design elements and how you do it. Use the principles as you would a recipe: The principles (recipe directions) tell you what to do with the elements (ingredients) and how to do it.

The four principles of design—balance, emphasis, rhythm and unity—help you combine the various design elements into a good layout. Each principle of design can be applied to all of the seven elements. For example, you could use line, shape, texture, space, size, value and/or color to create unity in a layout.

The principles of design influence each decision you make when creating a layout. They affect where you place your type and art, how each piece of art and block of copy relate to each other, what you show readers and how you show it. As you work with the design principles, keep asking yourself how each principle will help your layout work, make it attractive to viewers, and organize it to communicate the message clearly.

In this chapter you'll learn how the principles of design—balance, emphasis, rhythm and unity—help you *combine* the elements of design into a good layout.

Balance: An equal distribution of weight.

Babies learning to sit, stand or walk discover that they must maintain their balance—the equal distribution of their weight—or fall. Because our own balance is very important to us, we feel uncomfortable when we see something that isn't balanced. (We avoid leaning trees.) The same is true of a layout. If a layout isn't balanced, readers feel uneasy—they feel something is wrong with the page.

There are two approaches to balance. You can arrange elements so they're evenly distributed to the left and to the right of the center (one side mirrors the other just like a face). This is called symmetry. The other type of balance is asymmetry. You arrange dissimilar objects of equal weight on each side of the page. You can use color, value, size, shape and texture as balancing elements in an asymmetrical design. Because dark areas look heavier than light areas, a small black shape on the left would balance a large white space on the right.

Symmetrical balance can communicate strength and stability. It's especially appropriate for a traditional, conservative piece. Asymmetry brings contrast, variety, movement, surprise and informality to a page. It's especially appropriate for pieces that must entertain as well as inform, such as travel brochures.

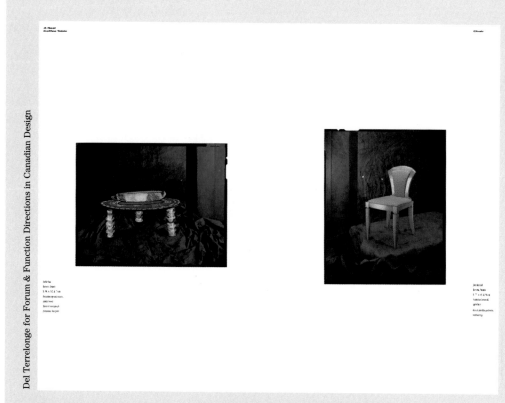

Del Terrelonge for Forum & Function Directions in Canadian Design

This spread is a classic example of formal balance or symmetry. The titles, the position of the images—which are carefully centered—and the copy appear in the same spots on each page. The diecut diamond is centered so it splits exactly in half. In fact, the pages are almost mirror images of each other; only the amount of copy varies slightly from page to page. Although perfect formal balance can be static, here it conveys an air of elegance appropriate to the fine furniture shown on the spread.

Exercise

Let's begin by working with formal balance. Cut six rectangles that are all the same size from one sheet of colored paper. They should be no larger than 3½" (9cm) wide by 2½" (6.5cm) deep. Lay an 8½"x11" (size A4) sheet of white paper horizontally across your work surface. Draw a line down the middle, dividing the sheet in half. See how many different ways you can arrange the six rectangles while making each half of the paper a mirror image of the other.

Explore asymmetrical balance now. Use the same sheet of paper for your background, but cut three rectangles 1"x 2" (2.5cm x 5cm) and three rectangles 3"x 6" (7.5cm x 15cm) from a single sheet of colored paper. See how many different arrangements you can make. Then, try layouts with the small squares cut from dark-colored paper and large squares cut from bright-colored paper.

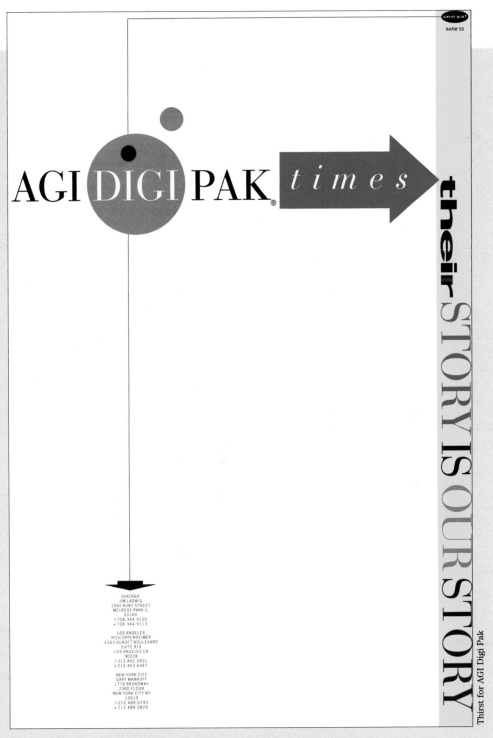

To create balance you can:

● Repeat a specific shape at regular intervals, either horizontally or vertically. (Make all the photos the same size rectangles and set them the same distance apart.)

● Center elements on a page.

● Put several small visuals in one area to offset a single, large visual or block of copy.

● Use one or two odd shapes and keep the rest "regular" shapes. (Put two photos in ovals and keep all the copy in square blocks.)

● Lighten a text-heavy piece with a bright, colorful visual.

● Leave ample white space around large blocks of copy or very dark photos.

● Have a large light area near the center of your piece while putting a small dark area near the edge.

● Offset a big, dark photo or illustration with several small bits of copy, each surrounded by plenty of white space.

● Divide your page into an equal number of columns or horizontal rows.

Asymmetry can bring variety, movement and surprise to a piece. The bright colors of (and behind) the type balance the white spaces. The lines, the arrow and the yellow band serve as framing and directional devices and offset each other's *optical weight* (their relative visual heaviness). Isolating the thin blue line with white space while tieing it to the arrow and type make it the same weight as all the other lines and arrows. Several intersections of varying weight, such as the red circle with the blue line and the blue arrow with the yellow band, also balance each other.

Rhythm: A pattern created by repeating elements that are varied.

We associate rhythm with music. A waltz has a smooth, flowing rhythm and a polka has a lively rhythm. There is also visual rhythm. A new picket fence has a steady, even visual rhythm—every picket is alike and the same distance apart. An old picket fence with gaps between the pickets that sags in places has a varied, uneven visual rhythm.

Repetition (repeating similar elements in a consistent manner) and *variation* (a change in the form, size or position of elements) are the keys to visual rhythm in layout. Repetition unifies a piece. Smooth, even columns of text make copy easy to read. But without variation, repetition can become boring. Pages of identical columns of text need to be broken up by heads or images. Balance repetition and variation, giving the reader enough repeated elements to bind the piece together, but vary at least some elements to keep interest high.

In layout, a piece's rhythm can communicate a feeling or mood. Placing elements at regular intervals (a smooth, even rhythm) establishes a calm, relaxing mood. This makes dry, factual text easier to read. Abrupt changes in the size and spacing of elements (a fast, lively rhythm) establishes an exciting mood. Ads often use a fast rhythm to catch and hold an easily distracted audience's attention.

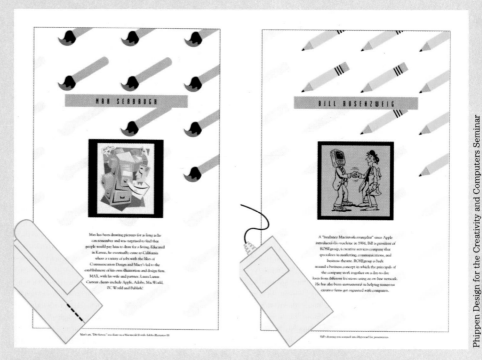

Phippen Design for the Creativity and Computers Seminar

There are two very different rhythms at work in this brochure. The centered placement of the artist's name, the illustration, and the copy create a steady rhythm that pulls the readers through the brochure. A second rhythm provides an interesting counteraction to the first. The small paintbrushes and pencils in the upper right hand corners have a very lively rhythm that breaks up the page. This adds an extra note of excitement to the piece.

Exercise
Rhythm is created by repetition with variation in an even or uneven pattern. Let's begin by looking at evenly moving rhythm. Cut six pieces of paper each ¼"x3" (.5cm x 7.5cm) out of one sheet of colored paper. Arrange them on an 8½"x11" (size A4) sheet of white paper so that all the pieces are parallel to each other with an equal amount of space between them. Place them close together (tight spacing) and then farther apart (open, or loose, spacing). Now try irregular rhythm. Using the same size pieces you had in the first part of this exercise, arrange them on a second sheet of white paper that's the same size as the first. But this time vary the spacing between the pieces. Compare your regular and irregular rhythms. Which feels more lively? Which is calmer? Which creates a feeling of motion?

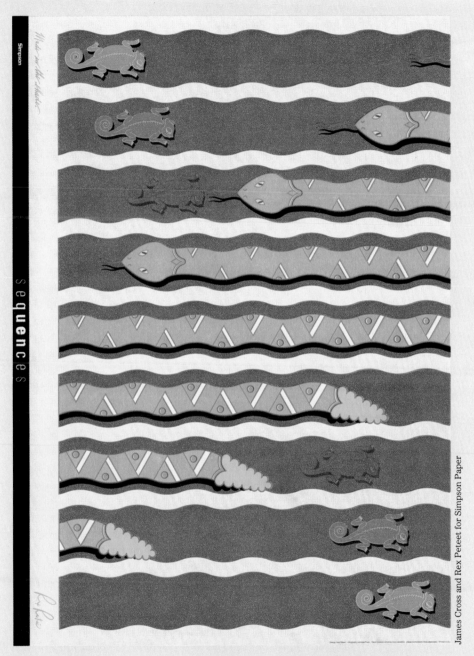

Simpson

s e q u e n c e s

James Cross and Rex Peteet for Simpson Paper

This poster is an excellent example of the ways repetition with variation can create rhythm. A number of elements are repeated: the squiggly bands and the pattern of triangles on the snake, for example. Variation is introduced by having the snake come farther into the poster in each band and then crawl out of it on the other side as the Gila Monster disappears before the snake and reappears behind it.

To create rhythm you can:

• Repeat a series of similarly shaped elements along the same baseline, with even white spaces between each (regular rhythm).

• Repeat a series of progressively larger elements with larger white spaces between each (progressive rhythm).

• Make all the text the same size (in the same-sized columns or boxes) but make the pictures different sizes (repetition with variation).

• Alternate dark, bold type and light, thin type.

• Alternate dark pages (with lots of type or dark pictures) with light pages (with less type or light-colored pictures) in a brochure.

• Repeat a similar shape in various areas of a layout.

• Repeat the same element in the same place on every page of a newsletter so the reader moves steadily through it. (Repeat a reduced version of the nameplate at the top.)

• Use a lot of elements with tight spacing between them, or a few elements with loose spacing between them.

Emphasis: What stands out most gets noticed first.

We emphasize what we want people to notice. We *emphasize* words by saying them louder or more distinctly. ("I *won't* go to bed!") We emphasize things we want people to see by painting them bright colors. (It's hard to ignore a *bright red* fire truck.)

In order to attract readers, every layout needs a focal point. Without one, viewers quickly move on. But if you have *too many* points of interest, your reader won't know where to look first and will give up. (In other words, emphasizing everything means you've emphasized nothing.) Therefore, you must choose the most important element based on the message you're trying to communicate and on your target audience. Making something large or bold just to have largeness or boldness doesn't work. A large, bad photograph might get a passing glance but will leave a negative impression on a viewer.

After you've chosen the element to emphasize, you can choose any of several methods to call attention to it. As a general rule, a focal point is created when one element differs from the rest. In a layout where everything is vertical, a horizontal element will stand out (a horizontal picture with vertical columns of type). A small, detailed illustration surrounded by a large area of flat color would form a focal point.

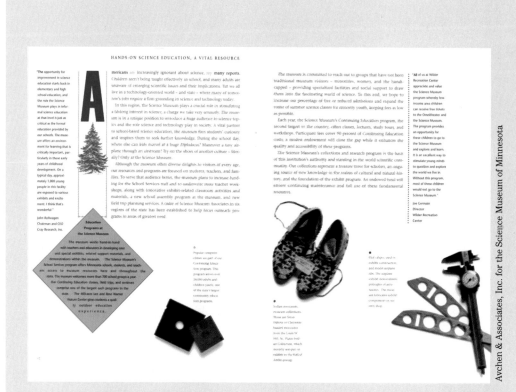

Avchen & Associates, Inc. for the Science Museum of Minnesota

The designer has used several techniques to create emphasis. A large capital letter marks the beginning of the copy. A tinted shape highlights a sidebar, colored bullets call attention to captions, and interesting quotes appear in red type.

Exercise

To emphasize something, you must make it stand out from what's around it. Let's create some examples of this. Tear pieces out of blue paper (any shape or size). Collage these pieces together on an 8½" x 11" (size A4) sheet of paper. Don't let any of the paper underneath show. Place one tiny piece of red anywhere on the page. Close your eyes and then open them again. Where do you look first? Now try the same thing, only this time make all your pieces of blue 3" (7.5cm) square. Lay them out anyway you like but make sure there's some white space left between them. Place a 1" (2.5cm) square of blue on one of those white spaces. Close your eyes and then open them again. Where do you look first?

Making a Good Layout

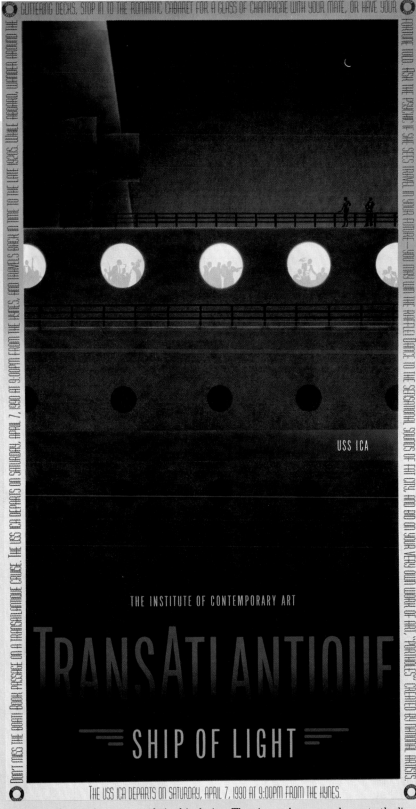

Lapham/Miller Associates for The Institute of Contemporary Art, Boston

Emphasis plays an important role in this design. The viewers' eyes are drawn to the line of lighted portholes where people can be seen having fun on the cruise. Setting the lighted areas off against the dark ship also reinforces the words "Ship of Light" in the headline. The dramatic, light colored, deco style type stands out from the background and plays up the "light" theme.

To create emphasis you can:

- Place a small element, such as a line of reversed type or a small photo, in the middle of a large area of black or white.

- Surround an illustration with a lot of text.

- Use a series of evenly spaced, square photos next to an outlined photo with an unusual shape.

- Put an important bit of copy on a curve or an angle while keeping all the other type in straight columns.

- Use bold, black type for a head or subhead and much lighter type for all other text.

- Place a large picture next to a small bit of copy.

- Put a shape that appears to be three-dimensional or a black-and-white photo against a field of flat color.

- Reverse the headline out of a black or colored box.

- Use colored type or an unusual face for the most important information.

- Put a list of benefits or a sidebar (a short article that supports a longer one) in a tinted box.

Unity: All the elements look like they belong together.

Some things obviously don't go together. You wouldn't wear swim fins with your best clothes. At other times, the problem is more subtle. A purse isn't the right color for a dress. A tie is too plain or too loud for a shirt.

Layouts need unity, too. Readers need visual cues to tell them a piece is a unit — this copy, headline, photo and caption go together. If there isn't organization of, or relationship between, elements on a page, you'll lose your readers. Imagine a grocery where the detergent was mixed in with the cabbages. You wouldn't know where to find what you wanted and you'd leave.

How do you unify type and images? *Grouping:* Elements that are close together look like they belong together. *Repeating:* A color, shape or texture repeated in the design pulls it together. Use a color from a photo as a background color. A *grid* (the subdivision of a space into columns, margins and spaces): It establishes a framework for spacing and proportions of type and pictures in a piece.

Variety keeps unified layouts from being boring. Begin with a theme such as circles. Then use circles and ovals in different sizes and shapes. Your elements are related yet varied to add interest. Use unity to hold a layout together and variety to give it life.

Making a Good Layout

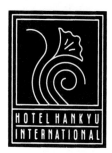
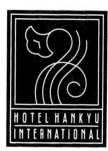
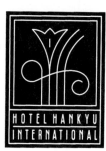

Pentagram Design, New York, for Hankyu Corporation Group

The designer unified this identity system by using the same technique and subject for each logo. Although each flower looks slightly different from the rest, they're still basically the same kind of flower and are executed in the linear technique.

Exercise

One way to unify a layout is to make the background color work with your visuals. Pick up paint chips in several colors at the paint store. Then cut out a colorful photo from a magazine. Lay the photo on a sheet of white paper and try different paint chips next to it. Use some chips that pick up colors in the image and some chips that don't. Which ones look best? They're probably the ones that picked up a *dominant* color from the image—those tend to work best together.

Another way to create unity is to use a grid as a framework for placing elements. Take a page from a magazine article. Draw red lines along the edges of the photos and columns of type. These lines represent the grid. Notice how the designer has used the grid. Where are elements placed? Do they run across more than one column?

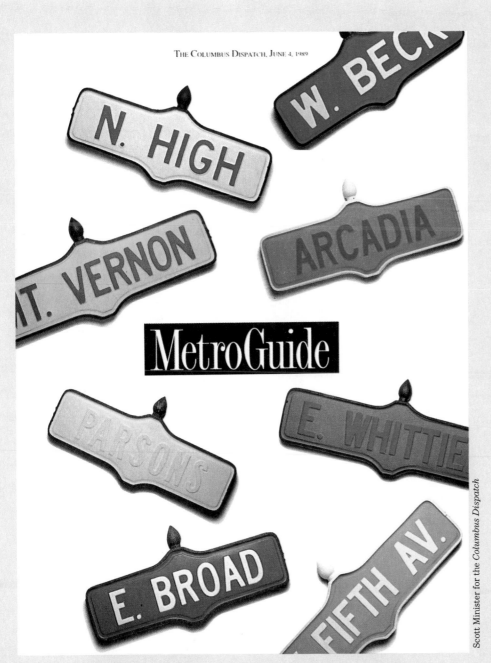

MetroGuide

Scott Minister for the *Columbus Dispatch*

Here, repetition becomes a tool for unity: The various street signs represent the different neighborhoods that make up the Columbus, Ohio, metro area but they are all tied together by being the same size and shape.

To create unity you can:

• Repeat a color, shape or texture in different areas of a spread or throughout a brochure. (Make all the photos circular or oval.)

• Group elements, such as a related headline, body copy, picture and caption, together.

• Pick visuals that share a similar color, theme or shape.

• Line up photos and copy along the same grid line(s) throughout a piece.

• Stick to one or two *type* families, varying only size or weight for contrast throughout a brochure or newsletter.

• Keep the type style you select for heads, body copy, photo captions and callouts consistent throughout.

• Use the same color palette throughout.

• Place callouts (quotes or sentences that summarize a piece, also called "pull quotes") near the section of type from which they were taken or to which they apply.

• Put a border around a poster, page or spread.

• Group elements with lines, screens or tints.

Conclusion:

The principles of design—balance, emphasis, rhythm and unity—determine what you do with each of the design elements . They influence every decision you make when creating a layout.

● Once you understand how these principles work, you can start applying them to your own layouts. Let's review what you've learned about the principles of design in this chapter.

● Balance: An equal distribution of weight. It helps determine the sizes and arrangement of the individual parts of your layout.

● Rhythm: A pattern created by repeating elements that are varied. It affects the shapes of and spaces between layout elements.

Emphasis: What stands out most gets noticed first. Emphasis influences choices of color, value, size and shape.

● Unity: All the elements look like they belong together. This helps

determine how many elements you use and how you use them.

Remember that the principles of design can be applied to

your layouts in many different ways because they can affect each

design element. Balance, rhythm, emphasis and unity can all

affect your choice of values—where those lighter and darker ele-

ments are placed on the page. Or to put it another way, you can use

each of the elements to create a balanced, unified, layout that has

the right emphasis and rhythm. The elements you use and how you

apply the principles of design to them will, of course, be deter-

mined by what the piece ought to do, how it will best be organized,

and what will make it most attractive to your audience.

Chapter 4
More Good
Examples

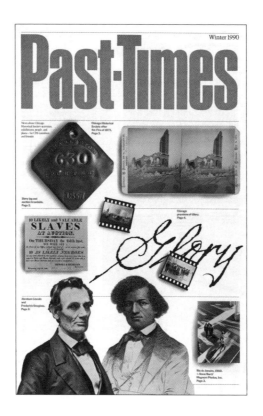

In chapters Two and Three we've looked at each of the elements and principles of design separately. In this chapter, you'll find examples of layouts in which the elements and principles have been combined especially well.

The pieces showcased here cover a range of design projects—newsletters, posters, brochures, letterheads, ads, logos and packaging. They were created by many different designers, and they show you a variety of approaches to the same kind of project.

Each type of project has its own special considerations. As you review these examples, ask yourself how each designer used the elements and principles to make a good layout, and ask also how they kept in mind the special considerations for that type of project.

We've included a brief overview of the design process for each project to help you understand what these designers did. Then you can apply what you've learned to your own layouts.

> This chapter showcases outstanding newsletters, posters, brochures, letterheads, ads, logos and packaging, and gives tips for creating your own.

Newsletters: Communicating information with style.

When designing a newsletter, you must create a format that will work with a lot of photos and copy. It has to be flexible to ensure attractive, well organized pages in every issue.

Use a grid that will unify the publication but still let you vary the look of each page. Try out typefaces and sizes until you find the one(s) that works for your material. Use only one or two typefaces in different sizes—for heads, subheads, copy, sidebars, captions, and jumplines ("Cont. on page 2").

How will you emphasize the nameplate (the title of and publication information for the newsletter)? Should the visuals be large or small? Will they be in outline form to give them interesting shapes or rectangular to fit better with the copy? (Always read the copy and place the visuals so they relate to it.) Will you use colored boxes to set sidebars off from the main copy and make them attractive? How else can you use a second color to emphasize or attract?

Make up a dummy—place photocopies of the visuals and type galleys (strips of type set one-column wide) on pages that show your grid—to see how your design works, fine-tuning it as needed. Always try to have no more than one-half of each page taken up by copy. Too much copy will make the pages hard to read and unattractive.

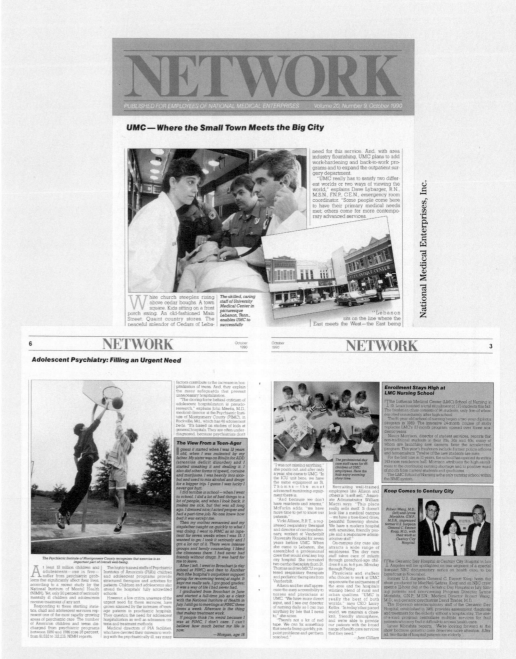

The nameplate has been emphasized on the cover with a band, and is then repeated in a similar style on the inside pages to unify the publication. To further unify the inside pages, the newsletter is very grid-oriented. The type is set in justified columns with rules in the margins between columns to visually separate them.

Making a Good Layout

A newsletter's design should:

- Be appropriate to the character of the client.

- Have a strong nameplate (also called a masthead) that lets the reader immediately identify the name of the publication and its purpose.

- Have room on the back cover for mailing information if it is a self-mailer—return address, logo, mailing label, "Address Correction Requested," and a stamp or pre-printed postal permit number.

- Each issue should have the same basic layout to show it's part of the series, but should look a little different to show it's a new issue. (Don't always have the same number of articles on a page or put a visual in the same spot on a page.)

- Invite the reader inside. (Put the table of contents on the front cover with a brief description of each article.)

- Visually separate headlines, subheads, body copy and captions by having a design for each. (Make headlines boldface but body copy roman.)

- Keep the design for each aspect of the piece consistent throughout. (Heads , body copy, etc. must have the same design on each page.)

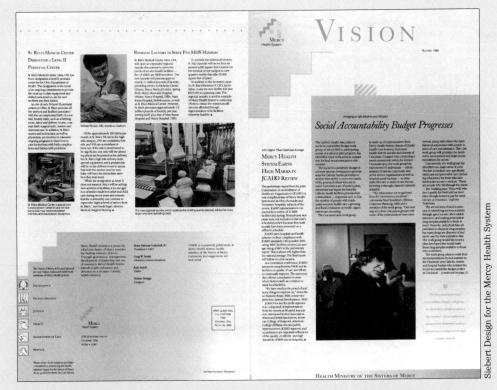

Siebert Design for the Mercy Health System

The shapes of the logo were repeated to unify this piece. The rayed squares signal the start of an article or sidebar. The stair-step shape sets off both the nameplate and the mailing area on the back page. (This newsletter must have the mailing information printed on it because it is a self-mailer—sent without a covering envelope.) Having the newsletter printed on both sides of one large sheet of paper—the two outside pages on one side (shown above), and the two inside pages on the other side—and then folded down to the desired size reduces costs.

Newsletters

Cox Enterprises, Inc., Atlanta, Georgia

The cover of this newsletter is well organized. Large type and a box printed in the second color (bright blue) behind the nameplate help set it off. The large illustration and the headline, part of which is also printed in the second color, pull readers into the lead article. Ample white space between the articles, and the large headline for the second article, clearly show where one article stops and the other starts. The table of contents is set off with the second color and will pull readers not interested in either of the cover stories into the newsletter.

Shapes add interest to an inside spread. One photo overlaps another and cuts it into an unusual shape. A rectangular box on the right and a rectangular icon on the left are turned at an angle to interrupt the flow of the page and catch the reader's eye.

THE HILL

August 1987

To sing or not to sing. That is the question to which freshmen often answer yes.

Why do so many freshmen choose the WMC Concert Choir as an out-of-class activity? First, there's the discovery that the guy with the basso profundo voice is dean of student affairs, Philip Sayre, and that booming soloist is James Lightner, professor of mathematics and education. Julie Badiee, associate professor of art history, hits the high notes, while Brenda Rickell, development office secretary, trills the tunes.

"Choir is a good way for freshmen to meet other freshmen and older students and faculty," says Beverly Wells, who is beginning her third year as choir director. A fourth of her 60-member choir consists of freshman voices, she says.

One of those first-year voices last fall was that of Rhonda Mize '90. "I was in the choir in high school, and wanted to carry it on," says the alto. "I liked it because it promotes interaction with professors and provides a common ground. And it's open to everybody. In choir you get involved right away."

The choir performs at college events, such as commencement and convocation, at retirement homes and other places around Westminster. But what Mize liked best was a swing through New Jersey last fall. This year Director Wells plans a similar jaunt through the Mid-Atlantic region.

Not only do freshmen get the chance to sing side-by-side with faculty, administrators and college staff, they can join the choir without proving they can hit b-flat. "There is no audition and no pressure to excel," Wells explains.

The veteran director cites yet another reason for the choir's popularity. "Freshmen join the choir because we are doing a mix of all kinds of music. Some of them come here expecting a college choir to be a high-blown affair where you sing only in Latin. But they find out we do spirituals, folk tunes, Gershwin. We combine the classics (such as "Honor and Glory" by Bach) with other styles of singing."

Wells wastes no time in bringing newcomers into her choral fold. Choir meets the first day of class, Monday, September 7, at 4:30 p.m. in Baker Memorial Chapel. Students may also join at a later date, and they can take choir for class credit.

Western Maryland College
A Private College of the Liberal Arts and Sciences in Westminster, Maryland

A second color (pale blue) and large type are used to set off both the nameplate of the newsletter and the dropped cap that starts each article. To make the piece more attractive, the columns vary in length, creating a lively rhythm as they wrap around the illustrations. On the cover, type is printed over an illustration that is done in the second color to also add interest.

"I hate this place. I want to go home. Mom and Dad just left and now I'm sitting here staring at all my unpacked stuff and these ugly bare walls . . .

I had to stand in this endless line of people to sign in and everyone around me was hugging and talking about their summers. I felt like the only living freshman on earth."

So writes Karen M. Rex '87, in her "Excerpts From The Diary of a College Student," one of 24 student-written essays where WMC students "tell all" about their experiences as college students on "the Hill." And these experiences are immortalized forever, since the 25 communications seniors, classmates in a senior seminar, have compiled the essays and published a 124-page book, *On Campus*.

"Publishing this book was much more complicated than the class and I had ever expected," says Mike Smith '87, who describes the project in the book's final chapter. Most senior seminars require a student to write a 25-30 page research paper but the course professor, Dr. Scott Eastham, presented a new challenge to his students. "Publishing a book is your opportunity," he told the seniors, "to live in a perfectable world. Editing, reviewing, and constantly evaluating a book lets you get as close to perfection as time, energy and attention permit."

The final manuscript was produced on the college's microcomputers, student-designed and printed locally. It sells for $2.95 in the college bookstore and the senior marketing team has mailed copies to area high school guidance counselors.

Contributing student authors wanted to focus on student life as something more than reading books and taking tests. "Living away from home, studying abroad, joining a Greek organization, are all experiences which educate the college student. It's the combination of these diverse factors which mold us into well-rounded, educated people," says student editor Leo Ryan.

Rex's diary, which Ryan says is the most interesting piece, concludes in the "Day 720" entry: "I love what I've learned here, and I've loved what this place has helped me make of myself. I admit I'm afraid to leave, but I can't wait to see what the world has to offer."

A limited supply of these books are available to interested students by calling or writing the Admissions Office.

2

Do you think football is big at Western Maryland?

You will when you're driving through Westminster on or about August 20 and notice all of the football players converging on campus for preseason camp. Despite recent off-years for the Green Terrors, football *is* big at Western Maryland, and will become even bigger this year this year if head coach Dale Sprague has his way.

Sprague, who has been at the College for a little more than a year, is calling some new plays that may make the football team better, as well as bigger. Last year, the Green Terrors dressed 69 players for the first day of camp. This year, Sprague anticipates at least that many *freshmen*. In total numbers, he estimates that as many as 120 gridders may drive up to the doors of Albert Norman Ward residence hall that August day.

Sprague's zealous energy is infectious. Not only did last year's team open camp with 69 players—it also ended it with 69 players, all of whom took an immediate liking to their new coach. "He really made us believe in ourselves. You can't help but get excited when you listen to him," notes last year's co-captain Peter Wilson.

Sprague carries the same fervor into his recruiting regimen. The hours of hard work have paid off—in large part, he says, because of the caliber of the College. "We felt that if we could get a prospect on campus to see our tremendous facilities and the quality of the people associated with Western Maryland, then we stood a better-than-average chance of getting him. Recruits are also impressed by the caliber of the competition Western Maryland faces: Johns Hopkins, Franklin & Marshall, and Swarthmore, among others.

Football players, however, won't be the only new athletes on campus this fall. In keeping up with the trends of the Eighties, the College has added women's soccer to its intercollegiate program for the fall. Joan Weyers, a veteran member of the WMC staff as an instructor and field hockey coach, will coach the team—bringing the total number of varsity teams to 20, 10 men's and 10 women's.

According to Weyers, "Women's soccer is a sport that is here to stay, and we are looking forward to the challenge a new team presents."

If you want a complete Fall Sports Schedule, call 301/848-7000, ext. 291, or write to the Sports Information Office, Western Maryland College.

If you've made the grade, then you may want to cash in on an academic scholarship at Western Maryland.

You may qualify for a scholarship if you have at least a 3.5 grade point average, a minimum combined SAT score of 1100, and have demonstrated exceptional creative talent or potential for leadership—in music, art, drama, writing or community service.

Each year the college awards more than $100,000 in academic scholarships to new students. Academic scholarships fall into four categories: the Trustee Scholarship is worth up to full tuition; the Presidential Scholarship is worth up to half tuition; the Dean's Scholarship is worth up to $3,000, and the Faculty Scholarship is worth up to $2,000.

Applying for an academic scholarship is simple. At the top of the WMC admissions application form is a box to check if you want to be considered for an academic scholarship. Those selected to receive scholarships will be notified by April 1.

If you do garner an academic scholarship you're still eligible for other forms of financial assistance. These include need-based grants or scholarships funded by Western Maryland, the federal government and state scholarship boards; federal student loans; and campus employment.

Myriad financial-aid options are one reason Western Maryland is included in *The Best Buys in College Education*—a selection of high quality, reasonably priced colleges by Edward B. Fiske, education editor of *The New York Times*.

For more information on financial aid, call (301) 848-7000, ext. 233 or write:

Financial Aid Office
Western Maryland College
Westminster, MD 21157

3

Newsletters

Past-Times

The numerous illustrations quickly attract the reader's eye on this spread. The shapes and sizes of the visuals are varied, and most have a drop shadow to give them a three-dimensional quality—as if they were floating above the page. Despite all this activity, the spread is still well organized. Thin rules and large dark type for the headlines set the articles off from one another. Drop caps in a second color (olive green) signal the start of each article, and a small icon in the second color marks the end of each article.

The cover is an illustrated table of contents to entice the viewer inside.

News about Chicago Historical Society activities, exhibitions, people, and place—for CHS members and friends.

Slave tag and auction broadside. Page 2.

Chicago Historical Society after the Fire of 1871. Page 3.

Abraham Lincoln and Frederick Douglass. Page 2.

Chicago premiere of *Glory*. Page 4.

Rio de Janeiro, 1960. © Rene Burri/ Magnum Photos, Inc. Page 3.

A House Divided takes a new look at the issues that nearly destroyed us

On this table, Robert E. Lee signed the surrender of the Army of Northern Virginia at Appomattox Court House, Virginia, on April 9, 1865.

Slavery. The issue the Constitution didn't resolve. The problem that divided and nearly destroyed the Union. The institution whose repercussions we still live with today. Slavery is the major focus of the long-awaited permanent exhibition *A House Divided: America in the Age of Lincoln*, opening here on February 4.

For generations, Chicagoans have come to the Society to see its outstanding collection of Civil War-era artifacts. Campaign banners and soldiers' diaries. Rare tintypes of black Union soldiers. The table on which Lincoln reportedly drafted the Emancipation Proclamation, and the bed in which he died.

These artifacts and many others were stored before the Society's modernization program began. Scholars and the public have eagerly awaited their reappearance. This completely new, more modern, and much more ambitious exhibition will be well worth the wait.

The diary of Silas Hardtley, a Union soldier, contains vivid descriptions of camp life and battle.

Providing context and viewpoints

"The idea behind *A House Divided* is to explain why the Civil War happened, to give people a sense of the context from which it arose, and its implications for the future," says Olivia Mahoney, associate curator of Decorative and Industrial Arts and co-curator of the exhibition. Working with her is Eric Foner, DeWitt Clinton professor of American History at Columbia University and a leading scholar of the Civil War era.

"In the middle of the nineteenth century, the nation was expanding, it was becoming industrialized, and it seemed to be flourishing," Mahoney continues. "But underneath, it was becoming increasingly divided—economically, politically, and philosophically. The central conflict was slavery."

A House Divided examines Lincoln's America, slavery and abolitionism, and the Civil War from many angles. The exhibition includes hundreds of powerful artifacts, from slave shackles and identification tags to a rare manuscript copy of the Thirteenth Amendment signed by Lincoln prohibiting "slavery and involuntary servitude."

There are biographical sketches of many whose lives are symbols of the age: Lincoln, Stephen Douglas, and Ulysses S. Grant, as well as lesser known activist Frederick Douglass, Chicago's leading black abolitionists, John and Mary Jones, and Mary Livermore, who organized civilian efforts to support the Union cause and later became a leading force in the struggle for women's rights.

A variety of media will help bring this history to life. Visitors can watch a lively video introducing the exhibition, listen to dramatic excerpts from soldiers' letters and the Lincoln-Douglas debates, and interact with actors portraying historical figures.

An exhibition that works

"This exhibition is a working resource," Mahoney says enthusiastically. "We have wonderful original material from nearly every collection at the Society. And it's all going to be out here for people to see, study, and learn from."

The Society expects record crowds—perhaps as many as three million people—to see *A House Divided* during the next ten years.

The exhibition has already broken records for support. A total of $300,000 from Kraft General Foods, the major private underwriter of the show, is the largest corporate gift the Society has ever received. The exhibition also received a $400,000 grant from the National Endowment for the Humanities, as well as major support from the Blum-Kovler, Amoco, and Regenstein foundations, and Crate & Barrel. Members will be receiving an invitation to two Members' Opening celebrations for *A House Divided* scheduled for Saturday, January 27, and Tuesday, January 30.

The Cubs are history!

Wondering what to do with your souvenirs from this year's season of dreams? You can help the Cubs take their place in history by donating your baseball souvenirs to the Chicago Historical Society. We're looking for mementos of this year's spectacular season, from unused tickets to t-shirts to home-run balls. Call 642-5035, ext. 330. Sorry, we can't take your shattered hopes. Maybe next year....

CHS Welcomes Charles T. Brumback to the Board of Trustees

The Chicago Tribune. The Chicago Cubs. WGN radio and television. What institutions are more intricately woven into the web of Chicago life? It seems only fitting that Charles T. Brumback, president and chief operating officer of the Tribune Company, the holding company of all these enterprises and more, should be named the Chicago Historical Society's newest trustee.

"We're very pleased to welcome Charles Brumback on board," says Society president Ellsworth Brown. "No single individual better represents so many of Chicago's great traditions—or so many of the Society's proud holdings."

The Society's collections do include a great many artifacts from the subsidiaries of the Tribune Company: copies of the *Chicago Tribune* dating from 1849, a quarter-century of WGN news film archives, and Cubs memorabilia from score cards to field seats.

"The Tribune Company is one of Chicago's pioneer corporations," says Brumback. "In archiving the history of the city, the Chicago Historical Society keeps alive the history of our company as well."

Before being named head of the Tribune Company in 1989, Brumback had served since 1981 as president and COO of the Chicago Tribune Company and a director of the Tribune Company. Prior to that he was president and CEO of the Sentinel Communications Company in Orlando, Florida, another subsidiary of the Tribune Company.

Brumback currently serves on the board of several Chicago-area institutions, including Northwestern Memorial Hospital (where he is chairman of the board of directors), the Orchestral Association, Northwestern University, and the advisory council of the Kellogg Graduate School of Management.

Reading the history of photography in the photographs of history

Many aspects of the Civil War set it apart from the conflicts that came before. It was the first major war to use the railroads to transport troops and supplies... the first to employ balloons, telegraphs, and hand grenades... the first to use modern, long-range rifles. It was also the first war to be extensively documented by the new art of photography.

Second only to Matthew B. Brady, perhaps the most prominent Civil War photographer was George N. Barnard. During a career that spanned five decades, Barnard mastered every new technique of photography, from daguerreotype to dry-plate paper photography. He worked with the most important figures in the field, from Brady to George Eastman. He was an early advocate of photography as an art form and a pioneer in the field of photojournalism.

Barnard's wide-ranging career is the subject of the exhibition *George N. Barnard: Photographer of Sherman's Campaign*, on view here February 9 through April 30.

The landscape of war

"Barnard was commissioned from November 1864 to March to document the battlefields," explains James Vlasek, assistant curator. The exhibition draws on the Hallmark Photographic Collection, Hallmark Cards, Inc., which is underwriting the exhibition. (Davis and Larry Vislocki), CHS curator of Prints and Photographs, are co-curators of the Barnard show.) "At the time, Barnard was an official photographer for the Union Army, assigned to follow in Sherman's footsteps and document the campaign."

But few soldiers are visible in these pictures. No battles are raging. No corpses litter the ground. There are only barren fields, shattered trees, and ruined buildings—the utter, empty destruction of war.

Rebel Works in Front of Atlanta, 1864. Albumen photograph by George N. Barnard.

Portrait of George N. Barnard, 1865.

Barnard's images are not the instant, action photographs of modern photojournalists. Rather, they are views carefully, sometimes artificially, composed to tell a story. They are, Davis says, "a synthesis of art and history. They tell an emotional truth."

From studio to battlefield to street

The exhibition, drawing on the extensive collections of the Society, Hallmark, and eight other institutions, explores a career of extraordinary breadth.

It begins with Barnard's daguerreotype studio portraits and street scenes, including a dramatic picture of a burning mill in Oswego, New York—one of the first news photographs. Later, Barnard would record stereographs of the devastation wrought by the Great Chicago Fire, among his shots are the ruins of the Chicago Historical Society.

Barnard was a pioneer in stereo photography. Samples of his work from Cuba and Niagara Falls are included here, along with his photographs of the early Civil War—the arrival of troops, the encampments, the trenches. His later stereographs from Charleston feature hand-colored landscapes of magnolia gardens and sympathetic portraits of freed black citizens at work.

"Toward the end of Barnard's career, he helped George Eastman develop and promote his new dry-plate negatives," Davis points out. "So he was involved in the development of photography as a commercial business, as well as an art.

"In Barnard's photographs, you can read the story of his life. And in his life, you can read the history of a half century of photography."

The Magnum Photographers: "Their studio is the world."

Black Panthers, Chicago, 1969. © Hiroji Kubota/ Magnum Photos, Inc.

There are two kinds of photographers," photojournalist Ernst Haas once said. "Those who compose pictures and those who take them. The former work in studios. For the latter, their studio is the world.... For them, the ordinary doesn't exist: everything in life is a source of nourishment."

Haas was speaking, of course, of his own profession. Since the Civil War, photojournalists have opened our eyes to the people, places, and events of their studio—our world.

Among the finest photojournalists of this century are the members of the cooperative known as Magnum Photos. Now, hundreds of their photographs have been collected in a traveling exhibition, *In Our Time: The World as Seen by Magnum Photographers*.

Gang members, Brooklyn, New York, 1959. © Bruce Davidson/ Magnum Photos, Inc.

Taking control

Magnum was founded in 1947 by photojournalists Robert Capa, Henri Cartier-Bresson, David Seymour ("Chim"), George Rodger, and William Vandivert. Working for publications such as *Life*, *Vu*, and *Harper's Bazaar*, these photographers were well aware that photography is anything but a transparent, objective medium.

They knew that every picture has not one meaning but many, depending on how it is used. And they resented the control that distant editors—often with viewpoints very different from their own—could have over the uses of their work. Editors made the assignments, selected the pictures and the context in which they would be shown, and wrote the captions. They even owned the negatives of pictures taken by "their" photographers.

It was a desire for independence and for professional integrity that created Magnum," says Prints and Photographs curator Larry Viskochil. "Magnum was an agency of, by, and for the journalists who created it. It gave them the power to decide what they would photograph and how it would be represented and sold. It allowed them to control their own visions."

A world of views

The five original Magnum photographers wove a diverse group with distinct styles, philosophies, and origins throughout Europe and America. As Magnum grew over the years—more than sixty photographers are represented in the show—the work of its members ranged even more widely.

In this exhibition, for example, you can not see only reports of nearly every major war since the 1930s, but Eve Arnold's haunting images of the Civil Rights movement, Chicagoan Bruce Davidson's intimate views of life on New York's East 100th Street, and Susan Meiselas's vivid reports from Central America.

In Our Time has been organized by the American Federation of Arts in cooperation with the Minneapolis Institute of Arts. It is touring simultaneously in the United States and Europe and opens at CHS on February 23.

2 *Past-Times*

This cover folds in half to become a square—an unusual shape for a newsletter, but perfectly suited to the dramatic cover image. Notice how the arms and legs not only pull the reader into the center but also call attention to each line of type on the cover.

Ample white space between and around articles and visuals gives the spread above a clean, organized look. The unusual edge of the photo on the left-hand page makes the spread more exciting and works well with the content of the photo.

A very flexible four-column grid becomes the structure for a calendar of upcoming events. Size plays an important role in organizing the page. The photos and the numbers for the year and month are very large so they'll grab the reader's attention. Larger lines and numbers set off the dates for events.

Gary Sankey for the Wexner Center for the Arts/The Ohio State Union

Newsletters

In this distinctive nameplate, the drop shadows behind and to the left of the letters, and the alternation of the thick and thin letters, make it look as if the type is moving. The illustration overlapping the type is unusual, but it ties the whole cover together. Placing a head inside a thick rule calls attention to it, and the designer continued to do this throughout the newsletter. Several other techniques are used for emphasis inside. Sidebars are set off with the second color (a warm red) or a mixture of the second color and black (a warm gray). The captions are set in all caps in a sans serif typeface while the copy is set in upper and lower case in a serif face.

Belk Mignogna Associates for Atochem North America

The cover of this newsletter relies on texture for impact: The line illustration background is very textural, and the nameplate seems woven into that background. To emphasize the table of contents, white lettering has been dropped out of black boxes so it will stand out despite all the activity in that background. Texture and value also play important roles on the spread. A rough, textured type is used for the main article's head. It represents the type of work done by the artists being profiled, and calls attention to main article so the reader will look at it first. For another article, type is reversed out of black to add interest.

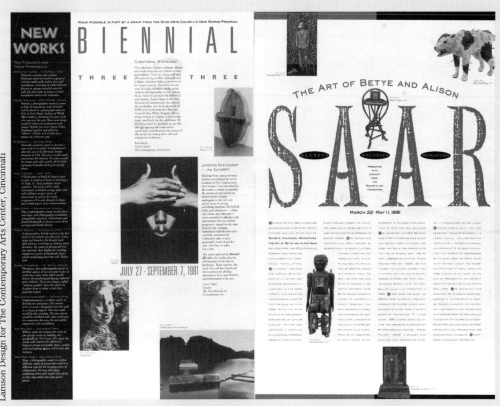

Lamson Design for The Contemporary Arts Center, Cincinnati

Newsletters

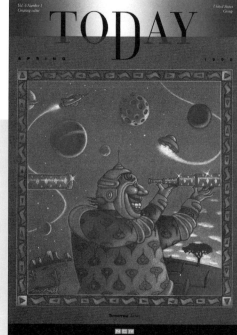

Siebert Design for NCR

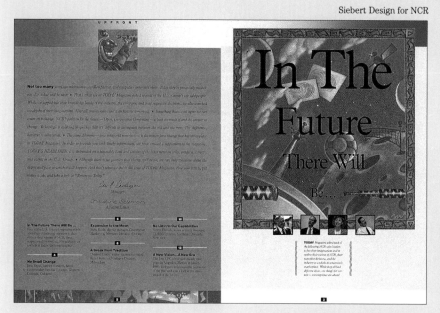

Some companies are moving away from traditional newsletters to more of a magazine format as shown here. Many elements remain the same, however—having the nameplate at the top and repeating an element throughout the piece (in this case bands at the top and bottom of the cover).

The table of contents has moved from the cover to the inside, but part of the cover illustration is repeated on the page to link it to the cover. The designers used the page facing the contents page to offer a sampling of what's inside the magazine. This continues to draw the reader into the publication—the function of the table of contents.

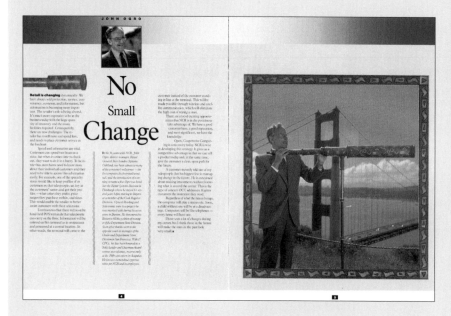

More techniques to unify a publication are seen here. The large photo is surrounded by the same border as the cover illustration. A photo breaks into the top band as did the illustration on the contents page. But while unity is important, so is emphasis. Wrapping the copy around the large headline emphasizes the article. Placing an illustration above the first line of bold type shows the reader where to start reading. A sidebar is set off by being centered and partially boxed by two sets of wavy lines.

This layout from a newspaper's Sunday magazine would work for a newsletter with a magazine format similar to *Network* (see page 42). It's a very simple layout with a sophisticated look that is created by the unusual type treatment and placement of the headline, the use of white space around the photo, and the choice of a rich looking, warm brown for the second color.

Posters: Capturing a moving audience with your message.

Although designing a poster offers a terrific opportunity to display your creativity, plan its layout carefully. You will have only seconds to attract a viewer's attention in a crowded environment. So, choose the *one* message your poster must convey and make everything work to communicate that message (unity) in the simplest, most direct way.

Then decide what will best convey the message visually. (In poster design a picture is always worth a thousand words.) Should it have one large visual? Or several small visuals with interesting shapes? What bright, bold colors will create the right mood or evoke the right emotion? Must some words be in large type to be easily read?

Also consider where the poster will be displayed and what size and shape it should be. Explore alternatives with thumbnails to find the most effective and dynamic visual imagery. Eliminate any superfluous detail. Work out the right size and placement for everything on the poster. Because you are usually working on a large scale, pay careful attention to balance and proportion. You don't need a full-size comp, but should do a reasonably large one to scale to catch any mistakes. This will also help your client appreciate how your poster will look when it's finished.

The main visual—a huge banjo that bleeds off the edge of this long, skinny poster—attracts because it's an unusual treatment of something ordinary. The banjo has such a distinctive shape that it is still recognizable even though part of it's not shown.

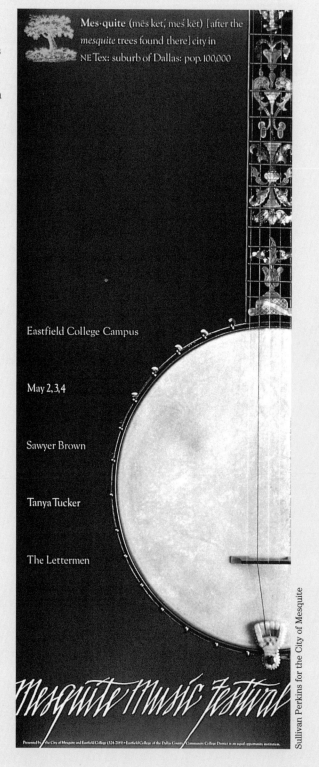

Mes·quite (mes ket, mes ket) [after the *mesquite* trees found there] city in NE Tex: suburb of Dallas: pop. 100,000

Eastfield College Campus

May 2, 3, 4

Sawyer Brown

Tanya Tucker

The Lettermen

Mesquite Music Festival

Presented by the City of Mesquite and Eastfield College (324-7059) • Eastfield College of the Dallas County Community College District is an equal opportunity institution.

Sullivan Perkins for the City of Mesquite

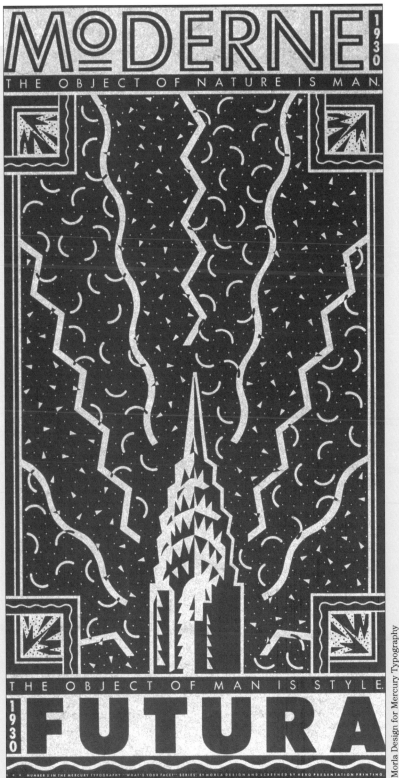

Morla Design for Mercury Typography

Line plays a starring role here. Wavy lines create a border at the top and bottom, the illustration style is linear, the headline at the top was given a linear treatment, and much of the background texture is created with short, curving lines.

A poster should:

• Have large type that can be read from the expected viewing distance (normally 10–15 times your format width).

• Have a simple layout. (Select a few key elements—type and visuals—so the viewer quickly gets the message.)

• Include all important information: date, time, place, etc.

• Have one dominant element—a headline, visual or logotype—that will quickly attract the eye.

• Have the most important message emphasized by size, color, or value.

• Have art that is closely related to its message or subject.

• Have its type and visuals arranged in logical sequence. (It should read from left to right or top to bottom.)

• Often have unusual or tight croppings on photos. (A tightly cropped photo can be reproduced larger, so it's easier to see.)

• Have bold, intense colors so it can be easily seen at a distance. (A poster meant to be seen only at close range can have more subtle colors.)

Posters

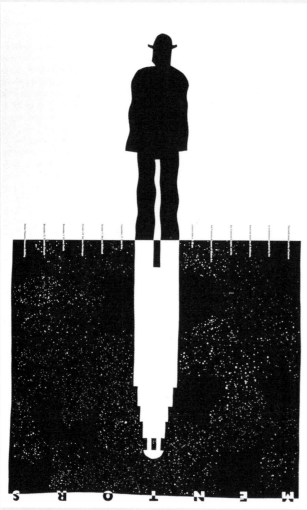

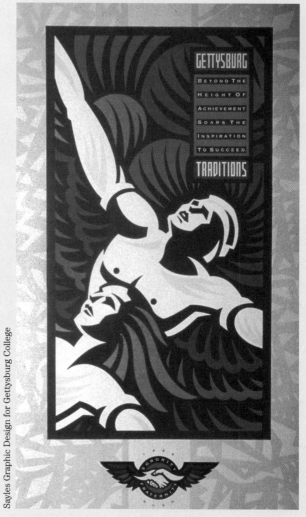

Vanderbyl Design for the American Institute of Architects, San Francisco Chapter, and the San Francisco Museum of Modern Art

Sayles Graphic Design for Gettysburg College

Space gives this poster impact. A white shape is cut out of the dark space at the top, and a black shape is cut out of the white space at the bottom. The white border surrounding the whole piece subtracts from the dark area and adds to the white area. This poster catches the viewers and makes them pay attention to the message.

The repetition of the curved, feather-like shapes creates an interesting background. The motion of the repeating shapes (echoed in the hair of the figures) creates a rhythm that leads the eye around the poster.

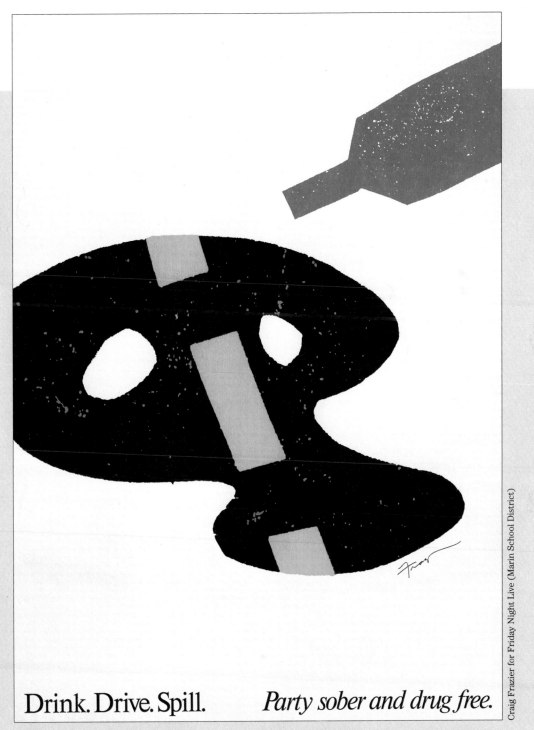

Drink. Drive. Spill. *Party sober and drug free.*

Space plays several important roles. Surrounding large, simple, strong-colored shapes and large type with a sea of white space makes the poster very dramatic and emphasizes the most important elements. Space also creates the negative shape of the skull (filled with texture that looks like asphalt and marked with yellow lines to represent a road).

Posters

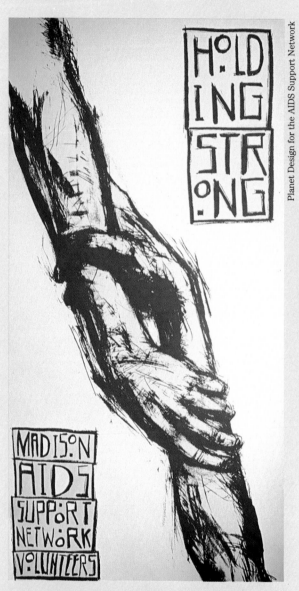

Planet Design for the AIDS Support Network

This is an unusual example of symmetrical balance because it is based on a diagonal splitting the piece. That strong diagonal created by the linked arms gives the poster drama and conveys a sense of strength.

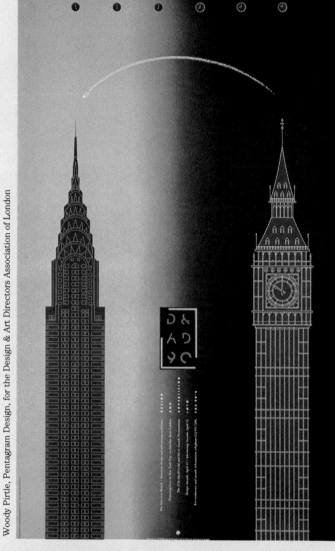

Woody Pirtle, Pentagram Design, for the Design & Art Directors Association of London

Using linear illustrations of both buildings unifies the piece and fits the message: A London design awards presentation will be broadcast in New York. The line that connects the buildings' transmitters is the signal. That you can bridge time and distance is illustrated by the line of clocks at top, and by the gradation from the sunset colors of the New York sky to the night colors of the London sky.

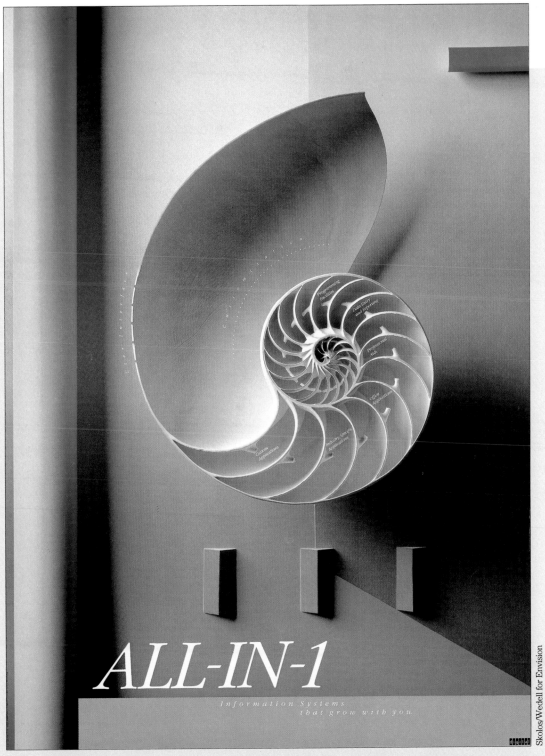

ALL-IN-1

Information Systems
that grow with you.

The gradations of color from light to dark, and the shadow areas, create a strong three-dimensional feeling and sense of space in this poster. Rhythm also plays a key role: Different rhythms are created by the sections of the chambered nautilus shell, by the repetition of the three-dimensional rectangles right above the headline, and by the type spacing and placement.

Posters

A variety of images (most are outlined and seem to float in space) help make this poster very attractive. Although the images are all different sizes and shapes, the layout is actually symmetrically balanced—there is equal weight on either side of the center. The door at the bottom, the window in the middle, and the type are all centered as part of this balancing act.

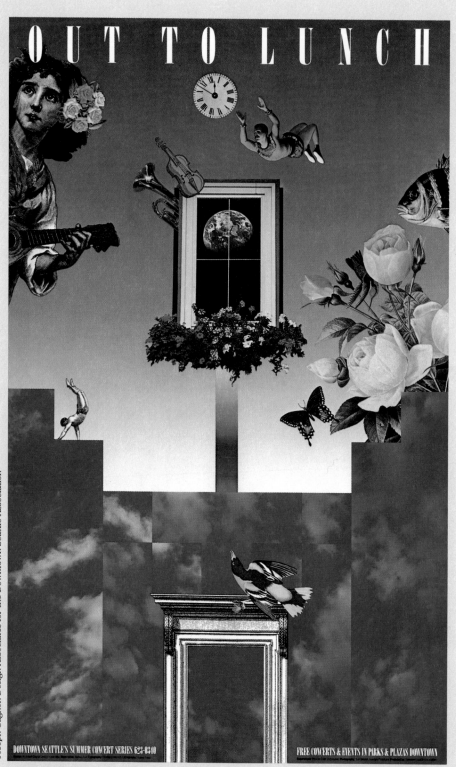

Joseph Gagnon Design Associates for the Downtown Seattle Association

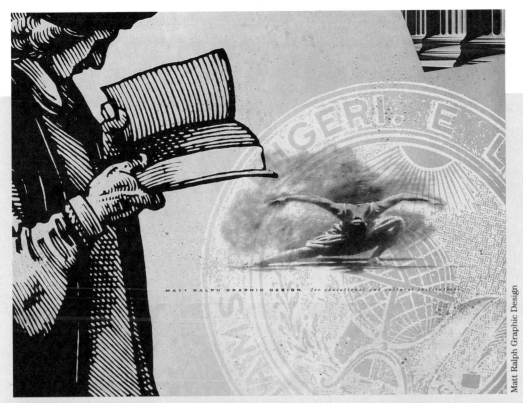

Matt Ralph Graphic Design

This layout is a good example of asymmetrical balance. The figure on the left is the largest, darkest image. It is balanced by the combination of the textured seal, the unusual crop of the small photo (top right), and the visual of the dancer that appears to float above the seal in the lighter portion. The poster is pulled together by the graded background color and the yellow texture that runs across the bottom.

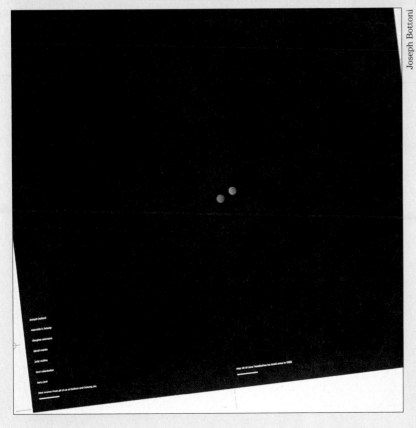

Joseph Bottoni

Emphasis makes the poster look attractive and also work. The two small spots of color—the aspirin—draw the viewer's eye. The contrast between the small, bright spots of color and the large, black shape is not only exciting but reinforces the headline, "May all your headaches be small." Dropping the small type out of the black calls attention to it.

Posters

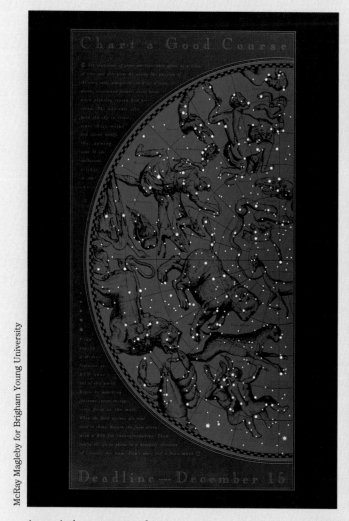
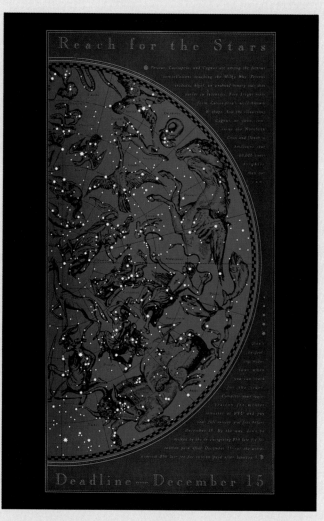

McKay Magleby for Brigham Young University

As a pair the two posters form one symmetrical unit—but each is asymmetrical. Each poster is quite effective as a unit, but together they are even more striking. The unity in color, value range, subject and illustration help pull the pieces together. The colors are rather muted and the values are held in a limited, darker range to reinforce the headlines and the illustration of the night sky.

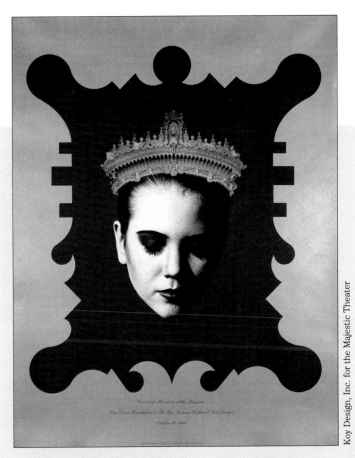

The shape surrounding the central image plays a key role in this poster's effectiveness (left). The shape attracts attention initially because it is unusual. Making it appear as if the woman's face is coming out of the black shape (value contrast) adds drama to the poster. The crown is emphasized because it is full color and shows its details against the solid color area.

The colorful shapes of the poster at the right convey motion and energy. They appear to be moving around in space because their colors make some leap off the background while others blend in. The space around and between them creates negative shapes that shows silhouetted figures.

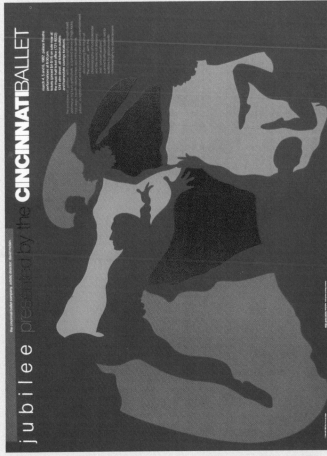

Brochures: Selling, telling or showing it to the client's audience.

A brochure is the most commonly used tool for public relations. Companies or organizations produce brochures to introduce, show or sell their products and services, or to educate, promote or persuade people to do something. A brochure must show and tell its story in a clear and interesting way, and contain all the information necessary for the reader to make a decision.

Decide what story your brochure should tell and who its audience is. Consider how it will be mailed or distributed. (See page 108 and 109 for questions to ask clients.)

Determine what visuals will best deliver the message. How many pages will you need to fit everything in and leave ample white space? What typeface(s) will be most appropriate for your audience?

Remember that unity is the key principle of good brochure design. You have to use consistent treatments for the type and the photos or illustrations. Each spread has to relate to the previous one and keep the story moving forward smoothly.

How can you use color to add interest if the brochure isn't four-color throughout? Should spreads be symmetrically balanced to look elegant or asymmetrically balanced to look lively? Can you use textures to make this piece "feel" different from competitor's pieces?

The designer used rhythm to add interest to the piece while preserving the clean, conservative look appropriate to this corporate client. The squares and photos are repeated throughout the piece, but the printing techniques vary (rhythm created by repetition with variation). The type is organized into blocks of copy that follow the rhythm set by the squares.

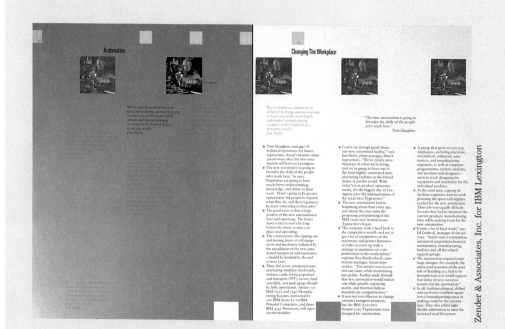

Zender & Associates, Inc. for IBM Lexington

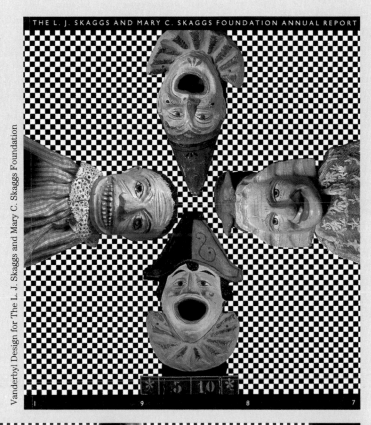

Vanderbyl Design for The L. J. Skaggs and Mary C. Skaggs Foundation

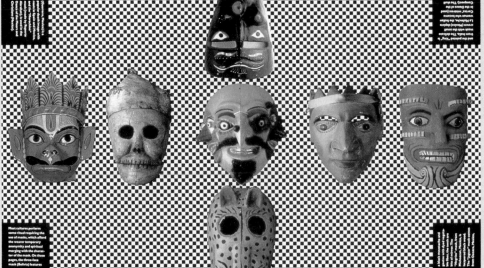

Symmetry plays a major role in the layouts of this piece. The images on both the cover and inside spread are symmetrically balanced. The copy that appears in the corner squares is also symmetrically placed. To keep the piece from looking too stiff and formal, a black and white checked background provides a textural contrast to the full-color masks and makes them pop off the page.

A brochure design should:

● Be unified throughout. (Use the same design elements, typefaces and styles. Also use the same grid on each page, but vary the layout.)

● Be designed for a long shelf life—several months to several years. (Don't use trendy colors in a brochure that will be used for several years: It will quickly look dated.)

● Have an inviting image or headline on the cover to draw the reader inside.

● Have the information arranged so it is easily understood. (People read from top to bottom, so headlines are usually at the top of a page.)

● Prominently display clear reader-response instructions including name, address and telephone numbers. (People won't order symphony tickets if they can't find the price and ordering information.)

● Be sized to best suit its purpose. (It should easily fit into an evelope for mailing or into a file folder if the client wants the recipient to keep it.)

● Have a careful and functional arrangement of its parts so the reader can move through it in an orderly fashion and understand what's being read.

Brochures

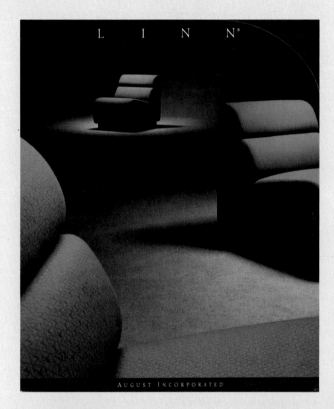

This brochure has been cut to take on the curving shape of the furniture. The free-form, textured shapes behind the photographs, the rounded corners on the inset photos, and the little icons also echo the product's shapes. All the background textures are those of the furniture's fabrics.

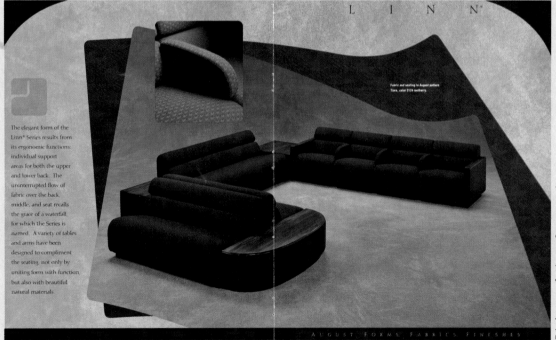

The elegant form of the Linn® Series results from its ergonomic functions: individual support areas for both the upper and lower back. The uninterrupted flow of fabric over the back, middle, and seat recalls the grace of a waterfall, for which the Series is named. A variety of tables and arms have been designed to compliment the seating, not only by uniting form with function, but also with beautiful natural materials.

Fabric and seating in August pattern Tiera, color 3124 mulberry.

Grieshop, etc. for August Incorporated

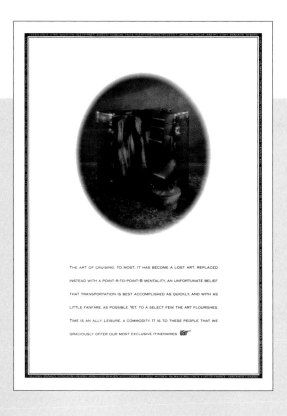

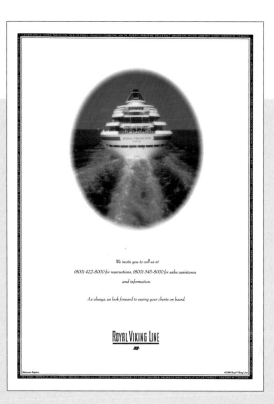

THE ART OF CRUISING. TO MOST, IT HAS BECOME A LOST ART, REPLACED
INSTEAD WITH A POINT-A-TO-POINT-B MENTALITY, AN UNFORTUNATE BELIEF
THAT TRANSPORTATION IS BEST ACCOMPLISHED AS QUICKLY, AND WITH AS
LITTLE FANFARE, AS POSSIBLE. YET, TO A SELECT FEW, THE ART FLOURISHES.
TIME IS AN ALLY. LEISURE, A COMMODITY. IT IS TO THESE PEOPLE THAT WE
GRACIOUSLY OFFER OUR MOST EXCLUSIVE ITINERARIES.

We invite you to call us at
(800) 422-8000 for reservations, (800) 346-8000 for sales assistance
and information.

As always, we look forward to seeing your clients on board.

ROYAL VIKING LINE

GRAND WORLD CRUISE

CIRCLE SOUTH AMERICA

IN THIS CENTURY, there have been a handful of travel experiences that bear little or no comparison—the Orient Express, the Ritz of Paris, the Concorde, and surely this, the crown jewel of the world's most elegant cruise line:

The Royal Viking Line Grand World Cruise.

Nothing can match it in scope, depth and sheer splendor. Here is the chance to visit thirty-eight ports, six continents and all the great oceans without once abandoning the pleasantries of civilization.

A rare privilege indeed, to see the birthplace of civilization and the tombs of Egypt's pharaohs, accompanied by some of the world's most respected scholars.

Or ride the Star Ferry across Hong Kong harbour, walk the cobbled streets of a Corsican village, or lie on Tahitian sands as white as the moon, knowing that at the end of the day a sumptuous five-course menu awaits—a menu never to be repeated throughout the entire voyage.

Or shop for silks and spices, rare gems and for those in the market, the camel bazaar in Djibouti still offers exceptional bargains. Then, later, toast such good fortune with a favored spirit.

But for all the Grand World Cruise has to offer, it is also an inward voyage, to the place deep within that, once upon a time, dreamed of taking such an incredible journey—a journey that remains, as it has always been, the accomplishment of a lifetime.

A VOYAGE AROUND SOUTH AMERICA is a passage of discovery. To the steaming jungles of the Amazon, home to more than 30,000 species of plants, and tributaries mightier than the Mississippi.

To the frozen peaks of the Andes, where the once secret shangri-la of Machu Picchu now stands revealed. And where ancient astronomer-priests once held captive the sun god, Inti, to insure his continued blessings upon the inhabitants of the Inca city.

To the land of prehistoric reptiles and the blue-footed booby, found nowhere else on earth except here on the remote islands of Darwin's Galapagos.

And finally, to the great Cape herself, bordered by glaciers and sailors' stories, passage to the western sea.

This is the route of Spanish conquistadores, of Sir Francis Drake and Captain Cook. It is the route to the great cities of the south. To Rio, Montevideo and the unexpected flair of European Buenos Aires.

It is a course of wondrous delight that begins the moment the gangway is lifted and the last streamers slip away.

At the rail will be passengers, a great many of whom have sailed with us before, passengers who recognize uniqueness when they see it, as evidenced in the destinations they are bound for, and in the gleaming white ship they have chosen to take them there.

Goodby, Berlin & Silverstein for the Royal Viking Line

Simple but effective techniques give unity to a brochure that becomes a poster when folded out. A border of type reversed out of black (listing many destinations) surrounds the front and back covers and all the inside spreads. The heads are also done in type reversed out of black and pick up the corporate typeface shown in the logo on the back cover. Large, dominant visuals and ample white space give the whole piece a consistent look.

More Good Examples

Brochures

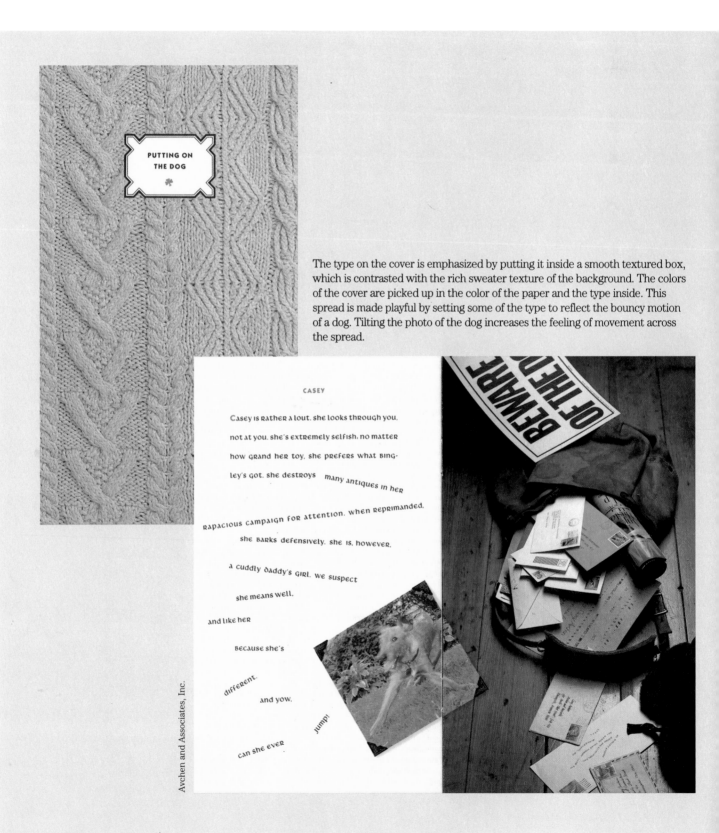

The type on the cover is emphasized by putting it inside a smooth textured box, which is contrasted with the rich sweater texture of the background. The colors of the cover are picked up in the color of the paper and the type inside. This spread is made playful by setting some of the type to reflect the bouncy motion of a dog. Tilting the photo of the dog increases the feeling of movement across the spread.

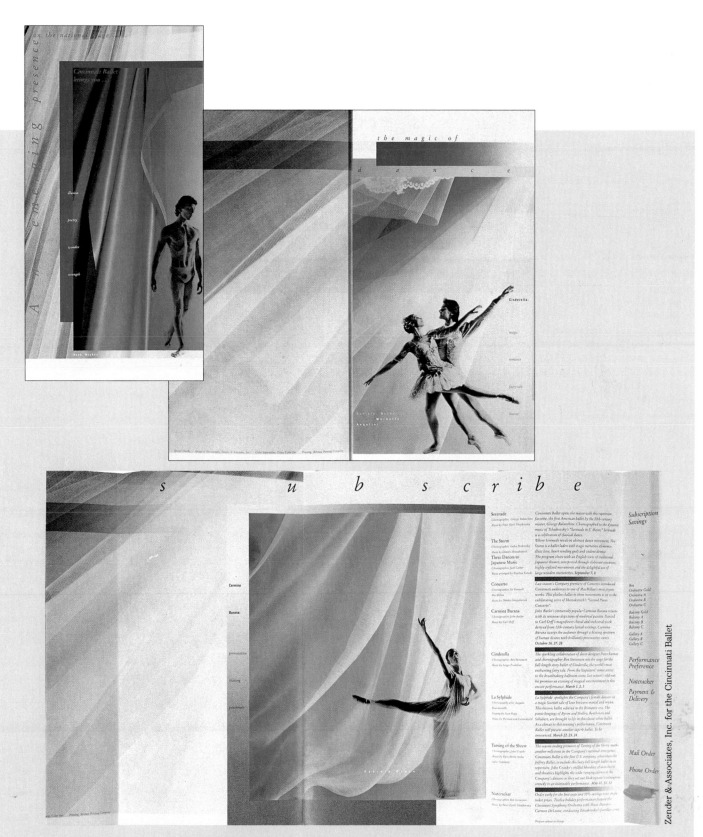

Texture and value are used to convey the qualities of a ballet. The fabric of a ballet costume becomes a soft, flowing background behind the dancers and in the white spaces of the pieces. Value contrasts give a sense of depth and motion: The dancers appear to float in front of the backgrounds and the graded bands flow across the pages.

Brochures

The texture embossed on the cover to give it a rich look is used throughout the brochure in the border surrounding blocks of copy. Captions are set in dark italic type with the texture as a background both to emphasize them and to separate them from the copy. Headlines are emphasized by being set in large type and placed inside an elaborate box. The beginning of each paragraph is set off only by extra spacing before a sentence and a dark initial cap, but the copy is still easy to follow.

Wages Design for Neenah Paper Company

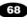

The lines and arrows that lead the viewer through the images on the front cover are used to direct the eye through the copy inside as well. Value contrast makes these delicate lines stand out from the background. Contrast between color and black-and-white reproduction makes the photo inside interesting.

UNIVERSAL FOODS CORPORATION

1990
ANNUAL
REPORT

*A Different
Kind
of
Food
Company*

COLOR

The Color Division experienced a strong year as a result of the full-year contribution from three companies acquired in 1989, as well as increased volumes from previously existing operations. A change in product mix to higher margin items, coupled with reduced raw material costs, contributed to improved operating profitability. The division's established Mexican operation serving Central and South America also continued to perform well.

Demand for natural colors remains very strong. Although natural colors account for only about 7% of current revenue, division management sees this as an area of great opportunity. The natural color market is a "high growth/high return" portion of the total color business which, itself, is in the "low growth/high return" category.

In 1990 the division began a multi-year capital improvement plan to ensure it will remain the leading North American producer of food, pharmaceutical and cosmetic colors. The first phase of the plan is construction of an $8 million dye production facility, with state-of-the-art, electronic process control equipment.

With a reputation for quality products and service and the largest market share in North America, international sales is the logical avenue for growth. Therefore, in 1990 the division began a concerted effort to increase such sales, particularly in Europe and the Far East. The size of the international market is comparable to that of North America.

Tumeric root provides
NATURAL COLOR
*for sparkling
yellow candies.*

FOURTEEN

FIFTEEN

Brochures

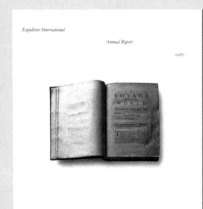

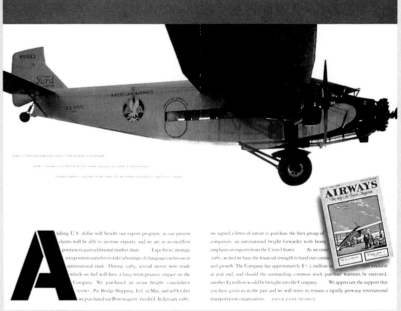

This simple, striking layout makes excellent use of white space to create impact. Isolating the visuals, which have been outlined to add even more interest, in a sea of white space calls attention to each in turn. Having a lot of open space keeps the layout from looking cluttered despite the large visuals and blocks of type.

The Van Dyke Company for Expeditor's International

A number of techniques are used to create emphasis. On the cover, the company's name and an explanation of its unusual corporate symbol are set off by a tinted box with a border inside it. This technique is used inside as well to set off sidebars and each section's opening page. Opening pages are also emphasized by large type for the head, an icon based on the corporate symbol, and a tinted background. Interesting tidbits of information are set in red type and have an icon above them to distinguish them from other kinds of copy— and to attract the attention of a browsing reader.

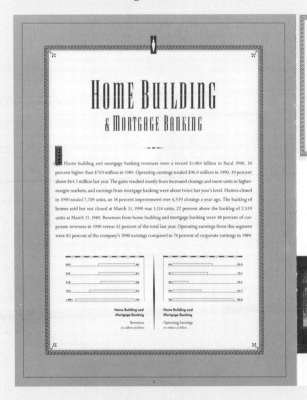

Peterson & Company for Centex Corporation

Letterheads: Expressing identity through stationery.

A good letterhead must express something of the character of your, or your client's, company or organization. At the same time, you must pack a great deal of practical information—name, address, logo, phone, fax—into it, and still leave ample space for a message on a sheet that's generally no larger than 8½"x11".

Because every client is different, each letterhead design should be as unique as a fingerprint. Get to know your client's personality and style in order to create an appropriate, effective design. Select the color(s), typeface, lines, shapes, and/or texture(s) that best fit that personality.

Look at possible positions on the page for the logo, name, address, and phone and fax numbers. Perhaps an asymmetrically balanced layout with the information running down one side or at the bottom would look best.

To check whether your design works (leaves ample space for a message), lay a sample letter reproduced on acetate over your layout to see that the design doesn't take over the whole sheet. Will the design also fit on a business card, envelope or mailing label? Also, did you emphasize the address, phone and other information so it can be easily found. Letterheads have to be attractive, but they must also work.

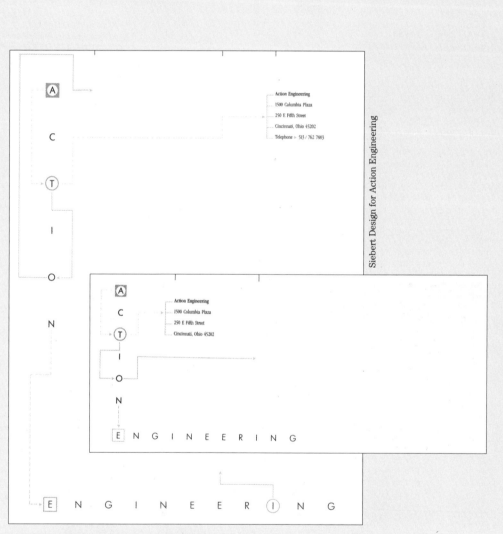

Siebert Design for Action Engineering

This design uses the lines and symbols normally found in flow charts to create a diagramatic logotype for an engineer. Note how the dotted lines and their arrows actually function as directionals connecting the letters *A* and *T* (*AT*) to the return address, while the solid lines and their arrows connect the letters *T* and *O* (*TO*) to the inside address.

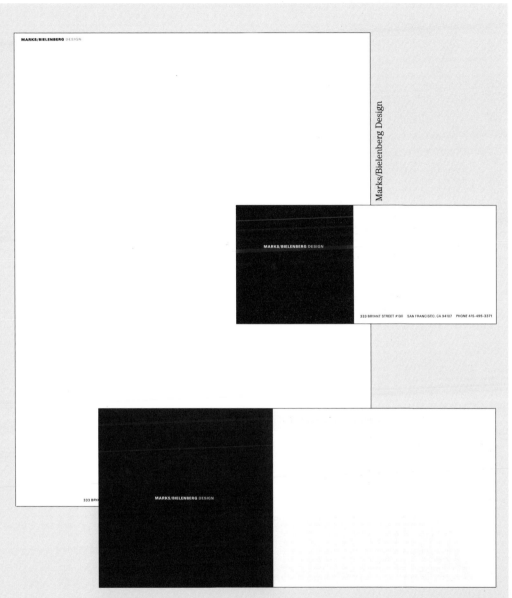

MARKS/BIELENBERG DESIGN

Marks/Bielenberg Design

MARKS/BIELENBERG DESIGN

333 BRYANT STREET #130 SAN FRANCISCO, CA 94107 PHONE 415-495-3371

MARKS/BIELENBERG DESIGN

333 BRYA

The strong value contrasts of the black and the white areas will make this envelope stand out in any stack of mail. The positioning of the studio's name was also careful-ly thought out: A typist can align the first line of the address with the preprinted name so that placement will be consistent on every envelope. The mailing label (top right) has been done the same way; but rather than centering the studio's name ver-tically on the label (the same distance from the top and the bottom), the designer positioned it higher to set the baseline for the first line of the address.

A letterhead system should:

• Clearly identify the sender by prominently displaying the name and/or logo.

• Display the sender's ad-dress and phone number in an easy-to-find location.

• Leave ample room for a message.

• Not overpower the content of a letter or make it hard to read—the purpose of a letter is to communicate.

• Reflect the client's charac-ter and personality. (A conser-vative client's letterhead should have a clean look and dignified feeling.)

• Have an envelope design that meets postal regulations for positioning of information.

• Make it easy to distinguish between the content of the message and the information about the sender.

• Have a design that works on all pieces—even a small business card.

• Include indicators on each piece that show where to place the inside address, salu-tation, and body of a letter; and also the address on en-velopes and mailing labels.

Letterheads

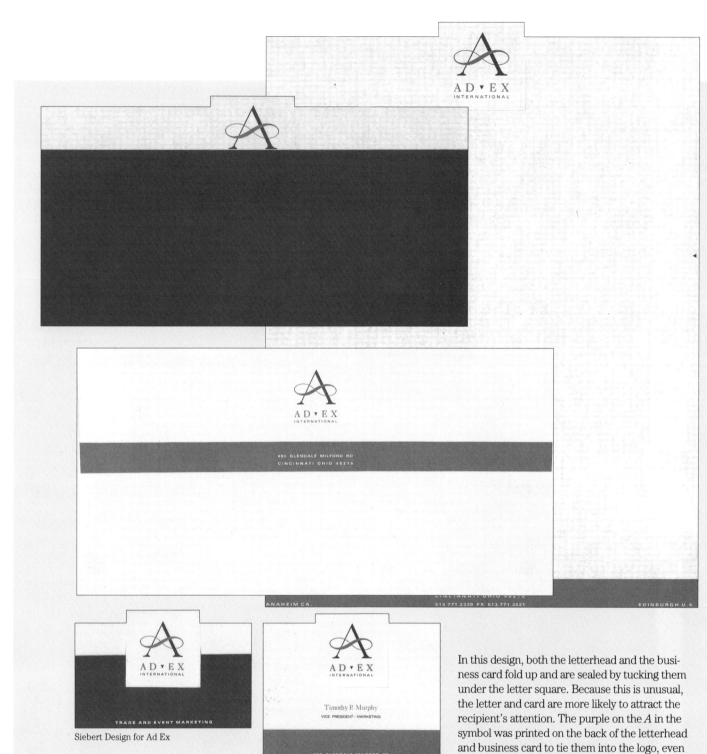

Siebert Design for Ad Ex

In this design, both the letterhead and the business card fold up and are sealed by tucking them under the letter square. Because this is unusual, the letter and card are more likely to attract the recipient's attention. The purple on the *A* in the symbol was printed on the back of the letterhead and business card to tie them into the logo, even when folded. Also for unity, the gold color of the *A*'s crossbar and the logotype was picked up on the edging of the envelope, and on the front of the letterhead and the business card.

Textures make this system very attractive. The paper has a nice, tactile texture. Some pieces are printed with a green, marbleized pattern for visual texture. The symbol is embossed and foil stamped (stamped with a film-like material that adds a metallic sheen or color, in this case gold) to the paper's surface, for both visual and tactile texture.

CORDELLA DESIGN

855 BOYLSTON STREET • BOSTON • MASSACHUSETTS 02116-2601 • 617 437 9198

Cordella Design

CORDELLA DESIGN

855 BOYLSTON STREET
• BOSTON MASSACHUSETTS •
02116-2601

• 617 437 9198 • FAX 617 536 6119 •

CORDELLA DESIGN

ANDRÉE M. CORDELLA

• 855 BOYLSTON STREET •
BOSTON • MASSACHUSETTS 02116-2601
FAX 617 536 6119 • 617 437 9198

Letterheads

PrimaDonna

300-A Globe Building, 407 East Fort Street
DONNA McGUIRE ☎ 313/964/5610
Detroit, MI 48226 FAX (313) 964•3953

This design is simple but quite effective. The red logotype stands out against the white background. Bright yellow boxes call out the return address on the envelope and the mailing label. On the back of the business card, the approach is reversed. A black box with the designer's name and phone number becomes the center of interest because it is surrounded by the yellow.

PrimaDonna

300-A Globe Building

407 East Fort Street

Detroit, Michigan 48226

(313) 964-5610

FAX (313) 964-3953

PrimaDonna

300-A Globe Building, 407 East Fort Street, Detroit, MI 48226

PrimaDonna

PrimaDonna

300-A Globe Building

407 East Fort Street

Detroit, Michigan 48226

Siebert Design for Krysdahlark Music

Each elegant, curvy shape not only suggests a musical quality but actually has a rhythm to it. Although the shapes add a special dimension to the stationery system, recent changes in the postal regulations would require that the shape on the envelope appear at the top or only on one side if it were used for bulk mail. For faster handling of bulk mail, the post office now uses a special machine that will not work properly if there is a tint or other material within one inch of the address label. The design would still be appropriate as it is for any client who didn't do a lot of bulk mail.

Letterheads

Lines and shapes add punch to this simple, two-color (black and warm gray) piece. The activity of the lines of the "scribble" balance the tint box that holds the address. (Although both areas look quite different, they are the same size.) The baseline of the word *design* literally ties the whole name together and links the name to the pictogram.

Making a Good Layout

maRGo
CHASE

213-668-1055
FAX: 213-668-2470

maRGo
CHASE
design

2 2 5 5
BANCROFT
AVENUE
los angeles
CA 90039

2255 BANCROFT AVENUE · LOS ANGELES · CALIFORNIA · 90039

design
CHASE
maRGo

An unusual format, a texture, and a classic layout create an elegant yet eclectic look. Make-ready (printed material left from preparing the press for printing) from three posters was collaged with an insurance form to create the textured background. Having the textured portion fold over the address is unusual and therefore eye-catching.

Letterheads

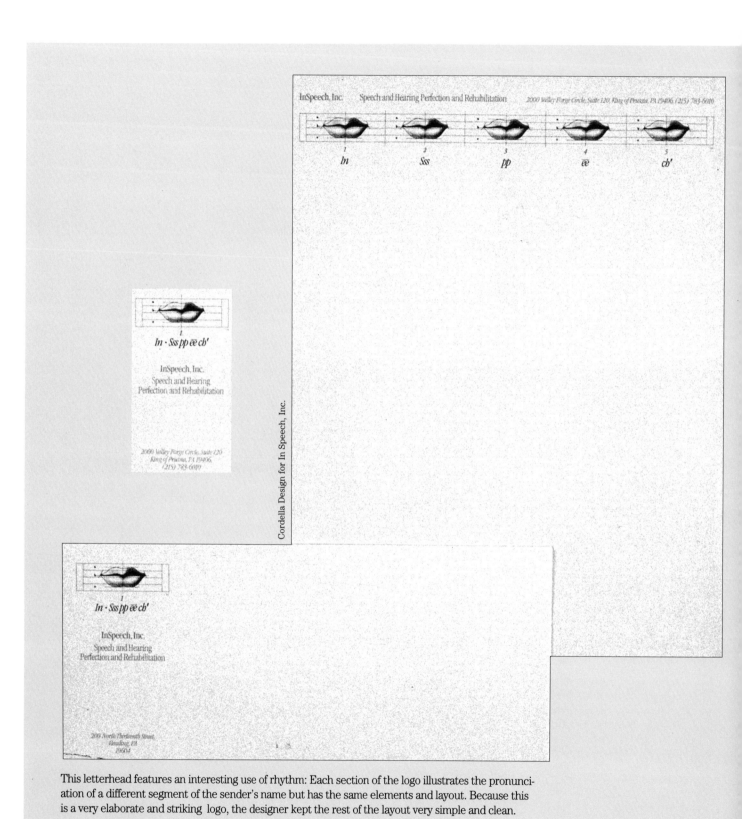

This letterhead features an interesting use of rhythm: Each section of the logo illustrates the pronunciation of a different segment of the sender's name but has the same elements and layout. Because this is a very elaborate and striking logo, the designer kept the rest of the layout very simple and clean.

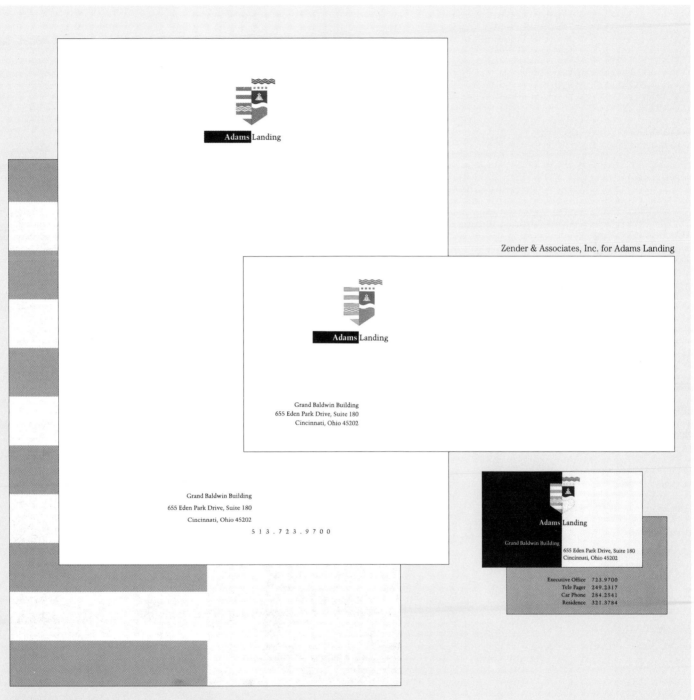

Zender & Associates, Inc. for Adams Landing

This letterhead design is very symmetrical, just like the logo. Notice how the black box that emphasizes the first part of the development's name is always set so the right edge of the box is aligned with the center point of the logo. On the front of the business card, instead of just a box, half the card is black to attract attention with a strong value contrast.

Ads: Showing and selling the product or service.

An ad is a *key* sales tool for any company and must therefore be designed with that company's objectives in mind. A target audience should be clearly defined *before* the design process begins. This way the ad will attract that specific group by catering to its needs, wants, and interests.

The first thing an ad must do is attract the viewers' attention, making them want to read further. Will the audience be attracted by strong value contrasts or pastel colors? Should you have a very large headline and central image? Should the ad have a lively rhythm or a calm one?

Next take into consideration the size and shape of your ad. How much space will you need for copy? Do you need to leave room for a coupon, and should you put a border around it to separate it from other items on the page?

Determine how to best organize the parts of your ad. What should readers see first, second, then third? How will you get them to read the ad in that order? Will you make the headline larger than the body copy? Will you set a coupon off from the rest of the ad with dotted lines?

Create a comp of the ad to see if everything works well together (balance and unity). Can the reader easily tell who the ad is from and how to respond to it?

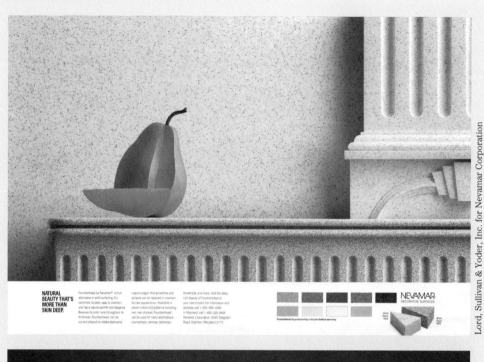

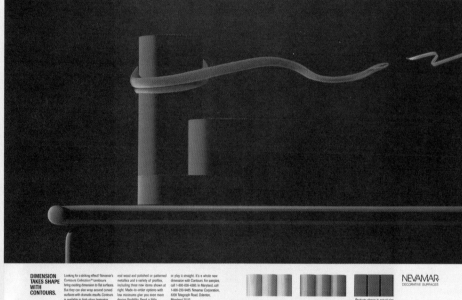

These two ads for one client's different products are unified by concept, and by the use of very similar layouts so the reader will associate both products with each other and with the client. The dramatic visuals pull viewers into the ad and reinforce the headlines with unexpected images. They are balanced by white space and the large shots of the product. The copy and additional product information are set off in a white band that makes them very easy to find and read.

Making a Good Layout

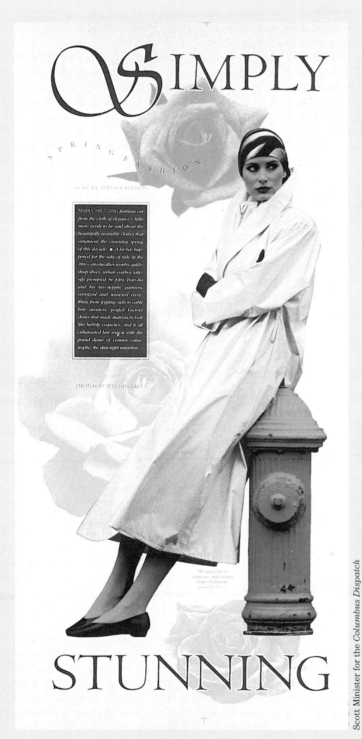

SIMPLY

STUNNING

This ad uses shape to attract. The outlined photos have interesting shapes, and the copy is set off with a black box. Space plays an important role, too. The ad has a lot of white space that gives it an open look and sets it off from the rest of the page. Layering the visuals over each other gives the illusion of depth.

An ad should:

• Prominently display the company's logo with its address and phone number where it can easily be found, such as the bottom right-hand corner.

• Make it as painless as possible for the reader to fill out and send in the coupon. (Always put the company name and address on a coupon if it will be clipped from the ad.)

• Have a large headline, a strong border or background, or a lot of white space to make it stand out.

• Make it easy for the reader to respond. (Include phone number(s), store hours, etc.)

• Emphasize the call to action. (Use darker type or place it in a box.)

• Deliver its main message simply and directly.

• Have a design that's appropriate to its content. (A bright, flashy ad won't sell many sleeping pills.)

• Be easy to distinguish from competitors' ads.

• Be based on a grid to make it easy to organize the elements and easy to vary their size, shape and placement.

Ads

Both these ads follow the classic ad format— a large central visual and a strong headline. Because of the size of the visual, each headline has been set in a colored box that has a wavy edge to give it more emphasis.

FOR PEOPLE WITH PARKINSON'S, THE BIGGEST PROBLEM IS STARING THEM RIGHT IN THE FACE.

While accepting that you have Parkinson's disease is never easy, dealing with others' reactions to it may be even more difficult.

The severe tremors, rigidity and problems with balance are very notice-able. And out of sympathy or mere curiosity, people stare. For someone with Parkinson's, though, this kind of attention is unwanted.

Too often it leads to acute self-consciousness and social withdrawal. Which may lead to depression.

We at the Wisconsin Parkinson's Association realize there are as many psychological obstacles to overcome as physical ones.

Through support groups, patients and their care-givers share how they adapt to their lifestyle changes.

WISCONSIN PARKINSON'S ASSOCIATION

It's also important to know that there's a place for information, which will go far to correct mispercep-tions and erase the stigma.

If you or someone you love has Parkinson's, con-tact us at (414) 225-8031.

To help us find a cure, send your tax-deductible contribution to the Seton Foundation, 2320 N. Lake Dr., Milwaukee, WI 53211.

It's time to realize that Parkinson's needs more than just a little atten-tion. It needs our under-standing and support.

Parkinson's disease is a disorder of the central nervous system. Yet the most crippling part may be the psychological damage.

As the symptoms pro-gress, patients can no longer do what they used to. Often, they fear they'll wind up helpless in a wheelchair, or die poor and alone. Many become isolated, beginning an in-ward spiral of depression.

At the Wisconsin Par-kinson's Association, we want to change all that.

Our first mission is education. We let people know what Parkinson's is *and* what it is not.

Through support groups, patients and their care-givers discuss common concerns and how to deal with them effectively.

WISCONSIN PARKINSON'S ASSOCIATION

We also offer medical support, so patients can see what means are avail-able to relieve the symp-toms. We want to increase research, and to change Medicare's policy on long-term reimbursement.

If you or someone you love has Parkinson's, con-tact us at (414) 225-8031.

To help find a cure, send a tax-deductible con-tribution to the Seton Foundation, 2320 N. Lake Dr., Milwaukee, WI 53211.

Rest assured, we can get through this together.

WITH PARKINSON'S, WHAT'S REALLY SHAKEN IS YOUR CONFIDENCE.

Emphasis makes these two ads very effective. In each one the photo is the biggest element so it will quickly attract attention. The headline is set in large type and surrounded by white space so readers will see it next. The name of the organization is re-versed out of a black box so readers will see it third (value contrast to create emphasis).

Ads

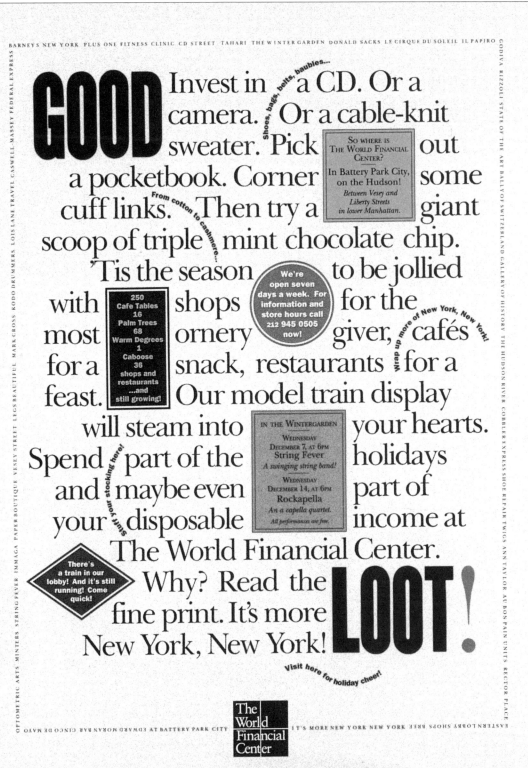

Lines and shapes give this ad a playful quality. Tidbits of information set in boxes that have different shapes and colors break up the copy in an interesting way. The little curved lines of type that look like streamers serve the same purpose. To hold the ad together, a line of type creates a border around the ad while the headline "Good Loot" is split in two to mark the beginning and the end of the copy.

Using stamps to represent cruise destinations is an unusual, but lively and colorful way to attract attention to a travel ad. To emphasize the company's name, the logo is the largest element in the ad. It breaks the border and looks as if it had been stamped on the ad. Emphasizing the logo also helps lead the reader to the call-to-action copy below it.

Ads

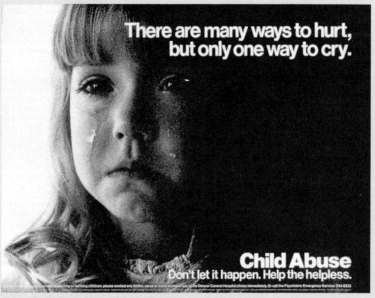

Robert Qually for the National Center for Child Abuse—Denver Dept. of Health & Hospitals

This strong, simple ad uses value contrast to reinforce its message. Setting the soft photo with its lighter values against the harsh black background highlights the photo and creates a somber mood. The asymmetrical balance works here because a photo always has more optical weight than an area of flat color.

The designer went with an unusual format for an ad—long and skinny, bleeding across the gutter—to attract attention. The ad is held together by the line (the tow truck cable) running across it that visually links the two parts. The large amount of white space and the brightly colored photo on the left-hand page (the truck is a bright red, white and blue) are nicely balanced by the dark type of the headline and the block of copy.

TBWA Kerlick Switzer for AAA Auto Club of Missouri

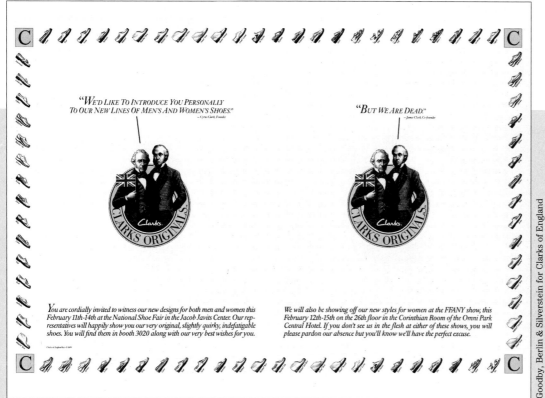

This ad uses large visuals and humorous headlines, emphasized by the large amount of white space that surrounds them, to attract the viewer's attention. The amount of white space and the use of symmetrical balance gives the ad a clean and classic, but inviting, look. The line of shoes that forms the border (repetition) not only holds the ad together but also showcases the client's product in an interesting way.

AAA Plus stretches free towing out to 100 miles.

For only $20 more a year, or $28 for families, AAA Plus can give you up to 100 miles of free towing, up to $1,000 back on emergency travel and legal expenses, $100 on parts and labor for emergency locksmith service, and more. So call your local AAA representative and ask about AAA Plus extended service. And see how far a few extra dollars can stretch.

Logos: Developing a symbol for communicating identity.

Begin the design process by learning as much you can about the client and its product(s) or service(s). Next, put all the information into a design brief. Define who your client is, what the client needs the logo to do, and how it will be used. Then turn the information into specific design objectives. ("The logo should project an image of reliability." "The logo must be inexpensive to produce because we have a small budget.")

Now you're ready to develop the design based on your brief. Explore different solutions, sketching out each one. Try typefaces with symbols to see how they work together.

Does a particular shape or type of line best convey the client's identity? Should the logo be big or small? Will strong value contrasts make it stand out better? Should it be formally balanced or have an exciting rhythm?

When you can't come up with any more ideas, review your designs and eliminate the least effective until only a few are left. Work with these to find the ideal color, size and placement of each element. See how each solution works for stationery, business cards, forms, or other applications.

When you've arrived at two or three best bets, it's time to prepare comps to show the client what the finished logo will look like.

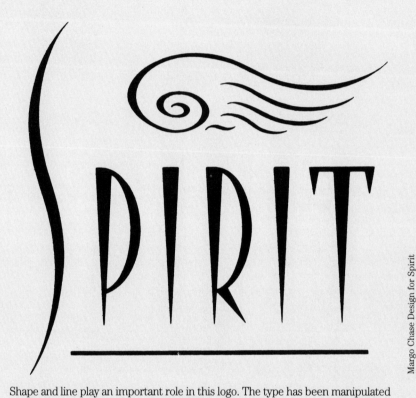

Margo Chase Design for Spirit

Shape and line play an important role in this logo. The type has been manipulated to give it flowing lines and an overall shape that is similar to the symbol to create a soft, delicate look.

Eisenberg & Associates for the Dallas Ballet

The Dallas Ballet logo combines a symmetrical symbol with symmetrical type, creating a logo that reflects the perfect balance of a dancer *en pointe*. This design works especially well because the words *DALLAS* and *BALLET* both have two *L*s in the middle and have not only the same number of letters but letters of equal *weight* (letter width and stroke thickness).

Making a Good layout

Siebert Design for the Musical Arts Center

Musical Arts Center

Texture adds interest to the leaf in this logo. Overlapping the leaf with the lines of the staff makes it appear as if the leaf is coming out of the musical staff.

A logo should:

• Be distinctive.

• Be appropriate for the client.

• Project a positive image of the client.

• Distinguish the company, product or service.

• Differentiate the company, product or service from other similar ones.

• Express the client's personality.

• Be legally protectable.

• Reproduce well in a variety of sizes.

• Work on all the applications the client needs (letterhead, forms, menus, signs, etc.).

• Have lasting appeal.

• Fit the client's budget in terms of number of colors.

• If typographic, be easily read at any size.

• If symbolic, be easily interpreted by anyone.

• Work in black and white and/or in color.

Logos

One *E* has been rendered as an elaborate, curvy line, while the other *E* has become a solid, blocky shape, in this simple, but effective, logo. It's also an interesting use of positive and negative shapes. Notice how the linear *E* appears to be cut out of the *E*-shape and the background. Notice how careful the letterer has been with the transitions from white to black where the linear *E* runs off the *E*-shape and onto the background.

Shape makes this logo work. Letterforms have been distorted to create a pictogram of *bark* to represent part of the client's name. The thick line underneath the logo holds all together despite the extra spacing needed around the pictogram. For unity, all the letters and the pictogram have lines the same width as the line beneath the logo.

Blackdog for Embarko

Making a Good Layout

Sibley Peteet for Milton Bradley

SCATTeRGORIeS

A collection of shapes popping out of a head gives this game logo a whimsical quality. Having little shapes explode out of the large shape of the head creates a sense of motion. Making the *E*'s smaller than the rest of the type is a minor change that adds a lot to the whimsical look of the logo.

Wages Design for Plus Development Corporation

Plus

Shapes and lines held together by negative space create the plus sign. The repetition of lines and shapes is combined with value changes from light to dark to give the symbol an interesting rhythm.

Dancing Bear Design

Repetition with variation makes the bear seem to dance in Dancing Bear Design's logo. Diagonals create a feeling of motion—the arms, legs and heads are positioned diagonally, and the shapes have jagged edges. The line that sets a border for the logo also seems to move.

Logos

This whole logo is made up of lines. Thin, thick, curved and straight lines create the abstract symbol of a city skyline with clouds above it. The word *Cities* has been rendered in a very linear style to blend with the symbol.

Agnew Moyer Smith for the American Institute of Architects/The Marketing Place

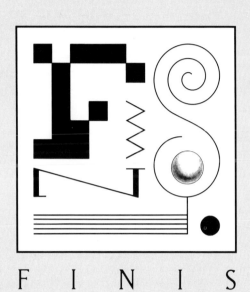

F I N I S

In this identity system for a post-production company, the company's name has been executed by using different shapes for the letters in each of three different symbols. Variety clearly distinguishes each one from the others, but the system is unified by always placing a box around the symbol, keeping the company name at the bottom, and using a spiral shape for one of the letterforms.

Siebert Design for Finis

F I N I S

F I N I S

Logos

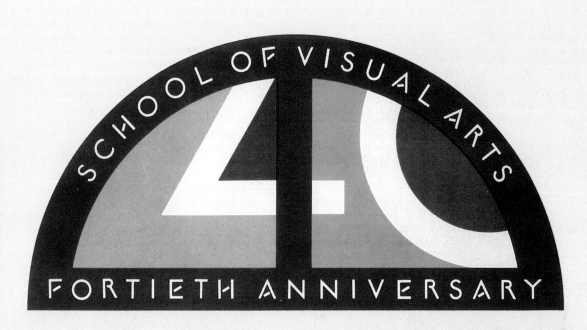

Milton Glaser for The School of Visual Arts

Cropping the 40 with the black, window-like shape creates an illusion of depth. The numerals were placed within the frame to make interesting shapes out of the spaces surrounding them. The type was reversed out of black to emphasize it.

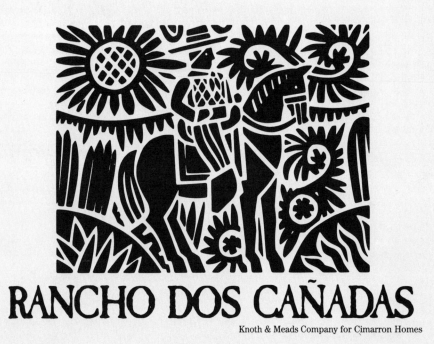

RANCHO DOS CAÑADAS

Knoth & Meads Company for Cimarron Homes

The arrangement of the symbols around the horse and rider gives this logo a strong visual texture. The type also has visual texture because of the rough edges of the letterforms. Both the type and the illustration styles are well-suited to the Hispanic theme of the logo.

Every part of the logotype is symmetrical horizontally and vertically. The plus sign is the center point of the logo and replaces the word "and" in both halves of the client's name.

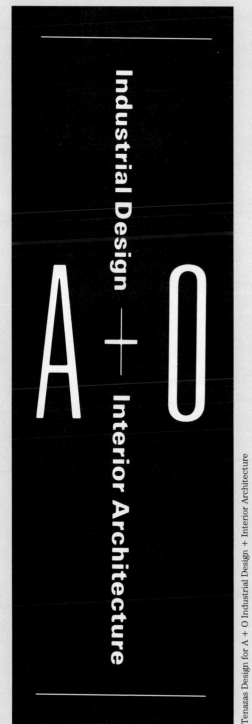

Industrial Design + Interior Architecture

Tenazas Design for A + O Industrial Design + Interior Architecture

Yamamoto Moss Inc. for Southdale Pet Hospital

Southdale Pet Hospital

The negative shapes cut out of the *S* create cute animal faces. This is a simple, strong approach that would work well in one or more colors.

Packaging: Standing out on the crowded shelf.

People often make a buying decision based upon which package catches their eyes. So, a great deal of thought and research goes into every package design.

A product is packaged for a certain market or audience. Designers research the target audience carefully, studying their likes, dislikes, buying habits, etc. They are also keenly aware of the competition. Similar products sit next to each other on the shelf, so each must have a design that separates it from the others.

The first thing a package must do is attract. Designers may use bright colors for an item that will be in a grocery store. Bottles with unusual shapes are sometimes used for skin care products to help them stand out.

Once customers pick up a package, they must be able to find information quickly. (What is the product? How is it used?) Information must be well organized, because people will put the product down if they can't find the information they need.

And the packaging must work. (Will the product pour easily? Is it safe from tampering?) If there is more than one product in a line, is there enough unity in the design so that customers can find them all without getting confused about which product is which?

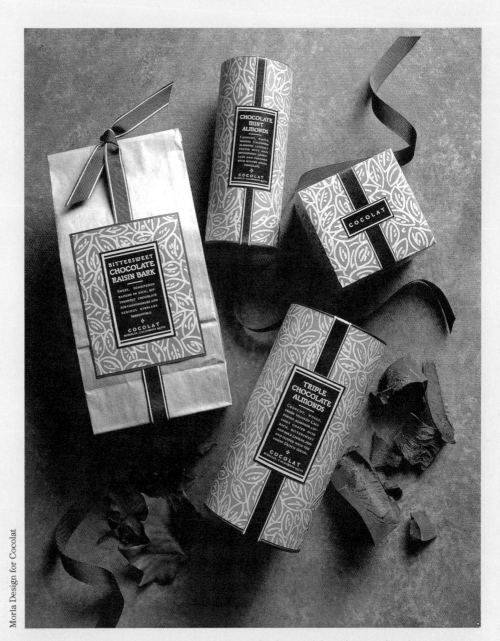

Morla Design for Cocolat

The stylized leaf shapes become a wrapping paper background (visual texture) and create a nice contrast with the strongly linear label and black ribbon. To help it stand out from the background, all the type has been reversed out of a black box. Emphasis helps organize labels that have product information. The name of the product is set in much larger type than the copy describing the product.

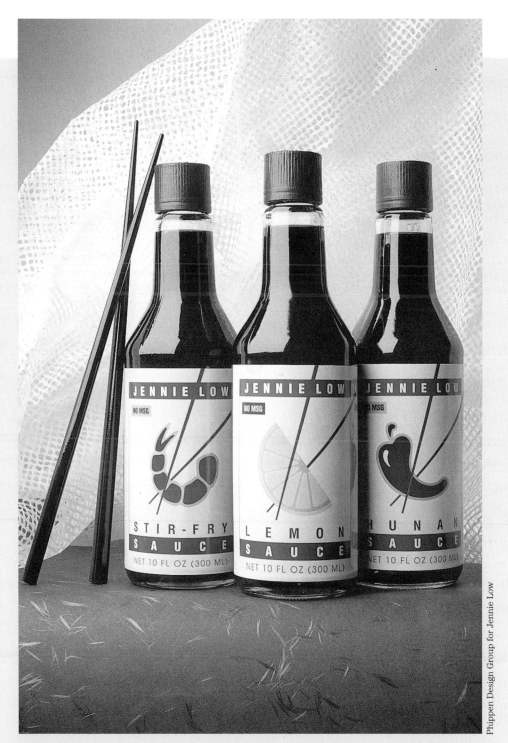

A package should:

- Stand out from its competitors when placed on a shelf.

- Protect its contents.

- Show an attractive visual of the product if appropriate. (Put a photo of appetizing brownies on the front of a box of brownie mix.)

- Highlight, in a *consistent* manner, differences such as flavors or styles, in the same line of products. (Use a different colored bar at the top of the package for each flavor.)

- Clearly identify its contents, the product's name, and manufacturer's name.

- Be easy to read.

- Have a design that works on all sides. (Don't make one side all blue and another all brown.)

- Convey the audience to whom the product is targeted. (On a package for a children's toy, show a photo of a child playing with it.)

- Reflect the personality of the store where it will be displayed. (A shopping bag or product packaging for an upscale store should look elegant.)

A package design must often unify a *line* of products, yet also create an easily distinguished identity for each product. All the bottles in this line of Oriental sauces have the same white label with purple bands at the top and bottom, and a single large visual in the middle. But each bottle has a different, product-related illustration to distinguish it from the other sauces.

Phippen Design Group for Jennie Low

Packaging

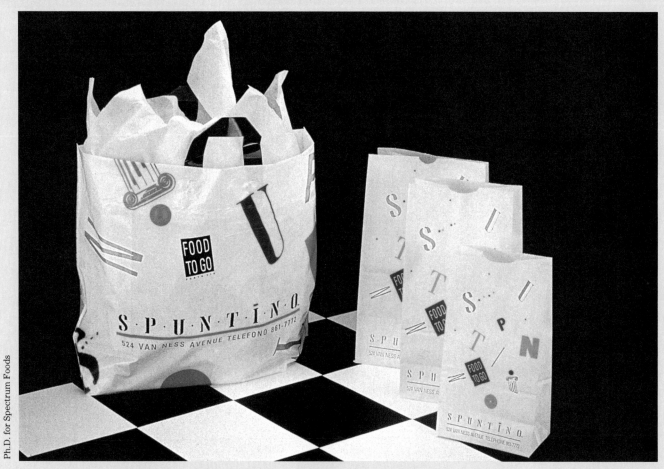

Ph.D. for Spectrum Foods

Lively illustrations and letters have been turned into shapes that float in a large white space to give these take-out bags a playful, airy look. Every shape is printed in a bright color to enhance the fun look. To keep from getting lost in the design, the clients' name is set in large type above a rule, and "Food to go" is set off in a colored box.

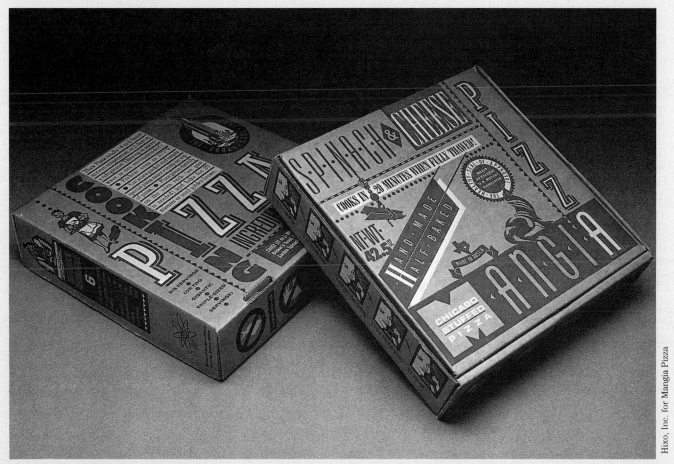

Hixo, Inc. for Mangia Pizza

This unique approach to a pizza box attracts attention immediately—without four-color printing. Putting as many different illustrations and uses of type as possible into the small area of the box lid (space) makes the box look exciting because there's so much going on. Varying the type treatments from one line of copy to the next and using all the illustrations as drop-outs (shape) also adds to the active feeling.

Packaging

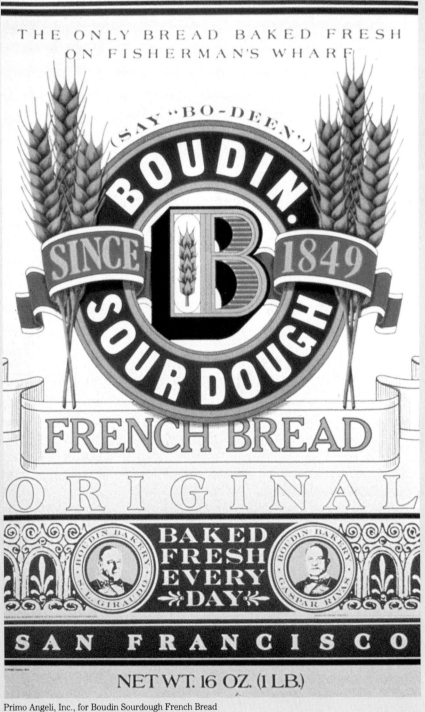

THE ONLY BREAD BAKED FRESH
ON FISHERMAN'S WHARF

(SAY "BO-DEEN")

BOUDIN.

SINCE 1849

SOUR DOUGH

FRENCH BREAD

ORIGINAL

BAKED
FRESH
EVERY
DAY

BOUDIN BAKERY
N. E. GIRAUDO

BOUDIN BAKERY
GASPAR RIVAS

SAN FRANCISCO

NET WT. 16 OZ. (1 LB.)

Primo Angeli, Inc., for Boudin Sourdough French Bread

This package has a very symmetrical design; even the type has been centered whenever possible. The piece is also nicely proportioned. The logo with its banner (the main illustration) plus the plain white background occupies two-thirds of the area of the package. This area is balanced by the activity in the bottom third of the package—a lot of type in a small space, a textural area, and very little white space.

Making a Good Layout

Primo Angeli, Inc., for Cambridge Ice Cream

This package design uses bright colors and large visuals to attract attention. To ensure that the product name and the flavor can be easily found and read, they have been placed inside a box. The type for each flavor has also been reversed out of a color to match the flavor (yellow for banana, for example).

Conclusion:

Learning by example is an important step to making a good layout. In the examples shown here, each designer made a good layout by selecting elements and principles of design appropriate to the piece, and to the message and feeling to be communicated.

- Let's review each kind of project and look at an example of how an element or principle of design might be applied to it.

- Newsletters: Communicating information with style. Emphasis can organize headlines, copy, and other elements.

- Posters: Capturing a moving audience with your message. Shape, color and value all help make posters attractive.

- Brochures: Selling, telling or showing it to the client's audience. Spreads must look balanced and have a unified look.

- Letterheads: Expressing identity through stationery. Because of the piece's size, the lines, shapes and type must fit well.

- Ads: Showing and selling the product or service. The main message must be emphasized in order to stand out on a crowded page.

- Logos: Developing a symbol for communicating identity. Choose colors, lines or shapes to express the client's personality.

- Packaging: Standing out on the crowded shelf. For unity, each side of a package must look like it's part of an overall design.

- When you make a layout, ask yourself the same questions you have asked about the pieces you have seen in this chapter. And you'll be making good layouts, too.

Chapter 5
Try It Yourself

In the first three chapters of this book we've looked at what a good layout is and what the elements and principles of design are. In Chapter 4, we looked at how these concepts are applied to a variety of projects. But there's a big jump from understanding how to do something to actually doing it yourself.

What do you do when a client calls you with a job? How do you get from the message the client wants to convey to a finished, good layout? How do you know when you've chosen the right elements and applied the principles the right way? How many different approaches should you try?

This chapter takes you through the development of an actual layout—through all the steps from the initial client meeting to collecting your copy and visuals to creating an actual layout. We've included all the copy and visuals you'll need to create several layouts, so you can explore different options with the designer. Try your own solutions, too. How will yours compare with the designer's?

In this chapter you can work along with a designer to make a good layout for an actual project, using what you've learned in the earlier chapters.

Step 1: Take a brief, interview the client, and get background information.

The first step on any project is to find out what the client wants. Meet with the client and ask lots of questions, gathering as much background information as you can. This is called taking a brief. Here are some questions that were asked by the designer on this project:

Q. What is the project?

A. We (the client) need an information brochure for our product, Colestid.

Q. What does the product do for the consumer?

A. Colestid is a granular food additive that controls or reduces serum cholesterol when incorporated into a person's daily eating routine.

Q. What is the purpose of this brochure?

A. We want this piece to act as a patient information guide and as a quick reference for the physician.

Q. Who is the audience?

A. Patients—men and women, ages thirty to fifty, who want or need to reduce or control their serum cholesterol levels—who will receive this brochure from their physicians.

Q. What is the main message of this brochure?

A. The main message is "Colestid usage fits conveniently into your normal daily routine."

Q. Are there sub-messages?

A. Some sub-messages in this brochure are that the product is tasteless and odor-

P R O J E C T B R I E F

Client Name: _____

Company: _____

Client Address:_____

Phone Number: _____

Fax Number: _____

Project Description: _____

Subject of project:_____

P a g e T w o

Project Purpose: _____

Main Message: _____

Other Messages: _____

Method of Distribution: _____

Project Budget: _____

Project Due Date: _____

Exercise:

On this page we have given you a form that you can use in any initial project meeting. This will help you remember the questions you need to ask and give you a place to record the answers. So, photocopy these two pages and keep them for future reference. (They'll be easier to use if you enlarge them to fit on the two sides of an 8½"x 11" sheet of paper.)

less, and it can be mixed with many common foods and drinks. Also, the brochure should reinforce the idea that Colestid is the best prescription option.

Q. Is there a feeling, a personality, you (the client) would like to give this brochure?

A. We want a "happy, scientific look," that is clean and simple and that a busy doctor can understand and quickly explain to the patient.

When you start a project, always ask:

- What is the project (project description)?
- What is the product or service being promoted or the information being conveyed (subject of project)?
- What is the project's purpose? Who is the audience?
- What is the main message?
- Are there any other messages to be conveyed?
- How will the product be distributed? Where will it be seen (method of distribution)?
- What is the budget? When must the job be done? (There may be no money for four-color illustrations or not enough time to create an elaborate layout.)
- What does the competition's literature look like?

Step 2: Get the copy from the client and begin planning the layout.

After you have your initial meeting with the client you need to start the ball rolling. This means getting the copy for the project plus any logos or symbols from the client.

While you are gathering these things, it is a good idea to start reviewing the information in your brief. How can you integrate everything into a piece that will work for the client, organize all of the product information, and attract potential customers? Here are some of the questions the designer asked herself to get started:

Q. What is the purpose of this piece and what can I do to make it work best?

A. The brochure is to act as an information guide for the patient and as a quick reference for the physician. Therefore, the information should be easy to follow and understand. The brochure should be easy to hold and file (such as a standard 8½" x 11" format). The page count should be small enough so that it isn't laborious to read, (maybe eight to twelve pages).

Q. How can I organize the information in the brochure?

A. The brochure will answer three specific questions about the product: what Colestid is, why the reader needs it, and how it is used. So, I will divide the information into three spreads—one spread for each question.

Making a Good Layout

CHANGE YOUR LIFE WITHOUT CHANGING YOUR DAILY ROUTINE

COLESTID Granules
colestipol hydrochloride for oral suspension, USP

Change Your Life *Without* Changing Your Daily Routine

THE BAD NEWS

High cholesterol is a serious problem. It is the single greatest risk factor associated with coronary heart disease, still the leading cause of death in the United States. For every 1% increase of cholesterol in the bloodstream, there is a 2% increase in the risk of coronary heart disease. And if you smoke or suffer from high blood pressure, your risk of heart attack or death from coronary heart disease increases markedly.

THE BAD NEWS

High cholesterol is a serious problem. It is the single greatest risk factor associated with coronary heart disease, still the leading cause of death in the United States. For every 1% increase of cholesterol in the bloodstream, there is a 2% increase in the risk of coronary heart disease. And if you smoke or suffer from high blood pressure, your risk of heart attack or death from coronary heart disease increases markedly.

Use **COLESTID** Granules (colestipol hydrochloride) daily to effectively lower cholesterol levels and significantly reduce the chance of coronary heart disease.

Use Colestid daily to effectively lower your cholesterol levels without changing your daily routine.

THE BEST NEWS

You may enjoy all the benefits that result from regular Colestid usage without changing your daily routine. Because Colestid is tasteless and odorless, it mixes well with many of your favorite foods and drinks...it can be any flavor you want. Because Colestid is not absorbed into the bloodstream, it causes no serious side effects...it will not slow you down. Colestid is the easy, flexible way to lower your cholesterol without changing your lifestyle.

THE GOOD NEWS

COLESTID, taken in the recommended daily dose, can produce a 16 to 24% reduction in LDL (low-density lipoprotein) cholesterol levels. For over 14 years ... in some 20 countries around the world...as evidenced in more than 50 medical studies involving thousands of patients...COLESTID has been proven to be a medication of first choice in the treatment of high cholesterol. COLESTID is the safe, sensible, effective response to the onset of elevated cholesterol levels.

THE BEST NEWS

You may enjoy all the benefits that result from regular COLESTID usage without changing your daily routine. Because COLESTID is tasteless and odorless, it mixes well with many of your favorite foods and drinks...it can be any flavor you want. Because COLESTID is not absorbed into the bloodstream, it causes no serious side effects...it will not slow you down. COLESTID is the easy, flexible way to lower your cholesterol without changing your lifestyle.

THE GOOD NEWS

Colestid, taken in the recommended daily dose can produce a 16 to 24% reduction in LDL (low density lipoprotein cholesterol levels. For over 14 years in some 20 countries around the world as evidenced in more than 50 medical studies involving thousands of patients Colestid has been proven to be a medication of first choice in the treatment of high cholesterol. Colestid is the safe, sensible, effective response to the onset of elevated cholesterol levels.

Exercise:

Let's look at some of the type options the designer considered for her layout. Notice the different ways she has handled or arranged the type for the same copy. How has she emphasized the headlines and subheads? How has she kept separate parts of the copy distinct? Does the type seem to help unify the spread? What elements of design do you think influenced her choices?

You'll need these type samples to work on the layout. Photocopy and enlarge the pages 200%. Cut out the samples neatly, following the edges as closely as possible.

On each spread the reader should read the headline first, then the rest of the copy. I will also highlight special information consistently from page to page.

I will also position the product's logo in the same place, and keep all of copy elements the same size on every spread.

Q. How can I make this brochure attract the product's potential customers?

A. The client wants to convey "a happy, scientific look" for the brochure. I agree, because it will make the piece more attractive. I can use photos and illustrations to help the copy communicate and to break up information so the brochure won't look like a medical journal.

I can also use light colors in the background and in the borders to help the piece look friendly.

There are many ways to use type to organize information and to help make the page attractive. I need to think about what size to make the headline so it will get noticed first. I must consider how to set off the subheads and the different kinds of copy. I will choose a typeface and decide what type style or styles will visually separate the information on the page.

Step 3: Choose design elements and look for or create appropriate visuals.

Before you start making lay-outs, decide which design elements will help your project work, and be organized and attractive. (If you need to, review Chapter Two.)

Here's how the designer of this project thought she could use each design element. (You will not always use all of the elements.)

Line: I can use rules to make the more important copy stand out. Or, I can use them as a border that goes around each spread of the brochure.

Shape: I can run a shape be-hind the product's logo so it stands out on each spread. I can also create interesting shapes by outlining illustra-tions and photos, and I can use these shapes to break up the copy so it will be easier to read.

Texture: I can use a subtle texture in the background for interest. Maybe the illustra-tions could be textured to make them more interesting.

Size: I can make the head-line bigger than the rest of the copy to emphasize it. If I keep the illustrations small, they'll fit with the copy better.

Value: I can use heavier type (a darker value) for sub-heads so they stand out from the body copy. I can reverse more important bits of infor-mation out of black squares.

Color: I will use color as a consistent element to visually hold the brochure together—

Making a Good Layout

1

1

COLESTID® Granules
colestipol hydrochloride for oral suspension, USP

Exercise:

Here are some of the visuals the designer considered for the first spread of the brochure. Review the elements of design she plans to use and decide how each potential visual fits with her thoughts.

You'll need copies of these visuals to work on the layout in this chapter. (The boxes with x's drawn in them represent photographs—which is what any designer would initially use on a layout.) Photocopy and enlarge these visuals by 200% and then cut them out neatly.

a light tint in the background, and a color in the borders that surround each spread. I can also use colored photos and illustrations to help the brochure look more attractive.

Space: Because the client wants the brochure to be full of information, I will fill up space with lots of pictures and copy rather than having lots of white space. This will make the brochure seem like a magazine, which will help give a friendly tone to the brochure.

Coming up with ways to use the design elements to communicate the message your client wants to make (as outlined in your brief), makes it easier to start on the next step. The designer for this project would now choose visuals or find an illustrator to create them—the route she actually took. (You would normally select your type and visuals at one time, but we've broken the process into two steps here to make it easier to follow.)

The designer knew she wanted some little illustrations and at least one photograph on each spread. Keeping in mind how she would use the elements of design, she looked for visuals that would illustrate points in the copy. Although she already had some ideas, she would come up with more when she experimented with different layouts—the next step.

Step 4: Experiment with different layout variations in small scale sketches.

.This is it, the time to combine the copy and the pictures and apply the design principles—balance, emphasis, unity, and rhythm—to all of the design elements.

To get started, try one layout variation for each of the design principles. Then try working with two of the principles, and so on. Come up with as many ideas as you can. Don't try to get any of the layouts absolutely right or completely finished. Make only small, quick sketches (called thumbnails) at this point.

When you feel you've run out of ideas, stop and review all the layouts you've created. Which combinations of the design principles and elements give you the most successful solutions? Which ones best communicate the message of the spread? Some layouts will be more successful than others, so put the less successful ones aside. Keep eliminating until you have only a handful left. Then work those out in more detail.

These are some thoughts the designer had about using the design principles:

Balance: All the layouts should be balanced so they'll look comfortable (friendly). Maybe the "bad news" and the "good news" copy could be paired symmetrically. However, the *pages* or spread should be asymmetrically balanced because of the amount

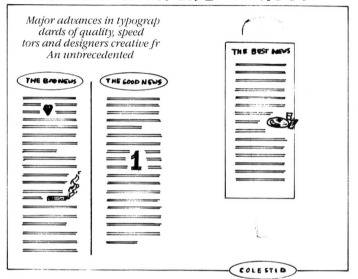

This is a good start. The headline stands out because it is bold (value) and placed at the top of the page. The symmetry (balance) of the left-hand page ties the two paragraphs together. A box and an exclamation point emphasize "the best news." The problem with this spread is that it lacks any visual excitement. It may need some photos.

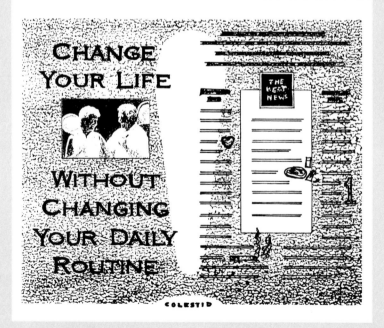

This version is starting to look visually more attractive because of the photos and the background texture. (The texture must be kept subtle so the copy will be easy to read.) The headline stands out because it is large and contained on the left-hand page.

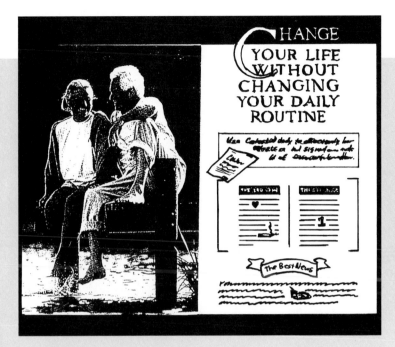

The big initial cap in the headline grabs attention. Size and shape organize the copy so it will be read in the right sequence. The paragraphs with the small illustrations lead the eye to the banner-style headline. This page is almost too busy, however. A unified type style will help simplify the page.

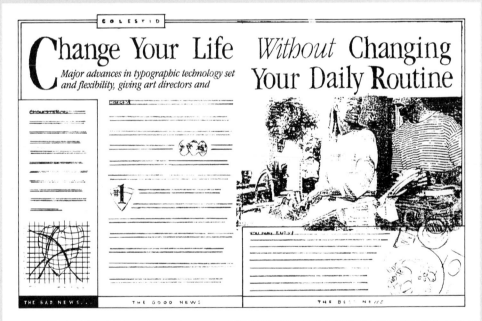

This spread is attractive and looks friendly. It is well balanced (asymmetrical). The large initial cap draws the eye to the beginning of the headline, which in turn leads you to the photo. The boxed information with the illustrated graph leads the reader into the body copy.

Exercise:

Try to make one of these layouts or the one shown on page 116 (the final layout). You'll need two sheets of 8½" x 11" paper, and photocopies of the visuals and type samples from this chapter. After you've tried one of these layouts, try some of your own. Photocopy each layout and then compare them to see how well you've applied the design elements and principles. Does each layout work? Is it organized and attractive?

of information. It would help direct the reader around the pages (organize) without making the pages look stiff and dull (attract).

Emphasis: This is going to play an important role in the design. I need to figure out what is most important and find a design element to highlight it. I can also use emphasis to divide the different parts of the copy.

Unity: I need to come up with a design element that occurs on each page to hold the brochure together. This way, even though the words and pictures change from spread to spread, you'll still know that each spread is talking about the same product — Colestid.

Rhythm: Maybe I can play with the subheads for each paragraph, "the bad news, the good news, the best news," because the way these are written suggests a rhythm in itself.

Finally, you should present the best layouts to the client as *comps* (complete, polished layouts with typeset copy and sample illustrations and photos cut from magazines or other sources). Choose two to four of the best layouts to show so you don't overwhelm your client. The designer for this project showed versions of the layouts you see here. Anything you show the client may be what is chosen, so never show a layout you're not comfortable with.

Step 5:

The layout of the actual printed piece.

The client liked the lower layout on page 115 the best. This doesn't mean the designer is finished, however. As you can see here, the designer made some further changes to the layout before it was printed. The right-hand page is almost unchanged, but the photo that was actually used is smaller, giving the page better balance and proportion. Although the headline still runs across the spread to help unify it, more of the head appears on the left-hand page to balance it with the photo.

The client agreed to cut the copy so the type on the left-hand page could be larger. Although the designer originally felt a busy, packed spread would be more attractive and friendly, she decided to leave more white space to create a relaxed rhythm that would be more soothing to a patient.

The designer responded to the client's concerns about how the piece would work (convey the message), how it would attract (appeal to the audience) and how it would be organized (what information the reader would find first). But each change was made with the design elements and principles in mind. Remember, to achieve the goal of making a good layout, always use these elements and principles within the framework of the type of project you're doing.

Siebert Design for Upjohn

Finally, it's done—and here's the actual printed piece.

Exercise:

Pick one of the layouts you did for the last exercise and make a comp (a final, complete layout with sample type and illustrations.) You can use the photocopies of the visuals and type that you've already made and clip an appropriate photo from a magazine. Make the finished piece as neat and attractive as possible, glueing or waxing all of your elements in place.

Now that you've learned the secrets of making a good layout, we hope you'll continue to practice what you've learned on every layout you create in the future.

Making a Good a Layout

Index:

Improve your skills, learn a new technique, with these additional books from North Light

Graphics/Business of Art

Artist's Friendly Legal Guide, by Floyd Conner, Peter Karlan, Jean Perwin & David M. Spatt $18.95 (paper)

Artist's Market: Where & How to Sell Your Graphic Art (Annual Directory) $21.95 (cloth)

Basic Desktop Design & Layout, by Collier & Cotton $27.95 (cloth)

Basic Graphic Design & Paste-Up, by Jack Warren $14.95 (paper)

Business & Legal Forms for Graphic Designers, by Tad Crawford $19.95 (paper)

Business and Legal Forms for Illustrators, by Tad Crawford $15.95 (paper)

Color Harmony: A Guide to Creative Color Combinations, by Hideaki Chijiiwa $15.95 (paper)

The Complete Book of Caricature, by Bob Staake $18.95

Creating Dynamic Roughs, by Alan Swann $12.95 (cloth)

Creative Director's Sourcebook, by Nick Souter and Stuart Neuman $34.95 (cloth)

Creative Typography, by Marion March $9.95 (cloth)

Design Rendering Techniques, by Dick Powell $29.95 (cloth)

The Designer's Commonsense Business Book, by Barbara Ganim $22.95 (paper)

Designing with Color, by Roy Osborne $26.95 (cloth)

Desktop Publisher's Easy Type Guide, by Don Dewsnap $19.95 (paper)

59 More Studio Secrets, by Susan Davis $12.95 (cloth)

47 Printing Headaches (and How To Avoid Them), by Linda S. Sanders $24.95 (paper)

Getting It Printed, by Beach, Shepro & Russon $29.50 (paper)

Getting Started as a Freelance Illustrator or Designer, by Michael Fleischman $16.95 (paper)

Getting Started in Computer Graphics, by Gary Olsen $27.95 (paper)

Getting the Max from Your Graphics Computer, by Lisa Walker & Steve Blount $27.95 (paper)

The Graphic Artist's Guide to Marketing & Self-Promotion, by Sally Prince Davis $19.95 (paper)

The Graphic Designer's Basic Guide to the Macintosh, by Meyerowitz and Sanchez $19.95 (paper)

Graphic Idea Notebook, by Jan V. White $19.95 (paper)

Graphics Handbook, by Howard Munce $14.95 (paper)

Handbook of Pricing & Ethical Guidelines, 7th edition, by The Graphic Artist's Guild $22.95 (paper)

How to Get Great Type Out of Your Computer, by James Felici $22.95 (paper)

How to Make Your Design Business Profitable, by Joyce Stewart $21.95 (paper)

How to Understand & Use Design & Layout, by Alan Swann $21.95 (paper)

How to Understand & Use Grids, by Alan Swann $12.95 (cloth)

Legal Guide for the Visual Artist, Revised Edition by Tad Crawford $8.95 (paper)

Licensing Art & Design, by Caryn Leland $12.95 (paper)

Make It Legal, by Lee Wilson $18.95 (paper)

Making Your Computer a Design & Business Partner, by Walker and Blount $27.95 (paper)

Preparing Your Design for Print, by Lynn John $27.95 (cloth)

Presentation Techniques for the Graphic Artist, by Jenny Mulherin $9.95 (cloth)

Print Production Handbook, by David Bann $16.95 (cloth)

The Professional Designer's Guide to Marketing Your Work, by Mary Yeung $29.95

Type & Color: A Handbook of Creative Combinations, by Cook and Fleury $39.95 (cloth)

Type: Design, Color, Character & Use, by Michael Beaumont $19.95 (paper)

Type in Place, by Richard Emery $34.95 (cloth)

Type Recipes, by Gregory Wolfe $19.95 (paper)

The Ultimate Portfolio, by Martha Metzdorf $32.95

Using Type Right, by Philip Brady $18.95 (paper)